SPRINGFIELD'S
·········· *Celebrated* ··········
HORSESHOE SANDWICH

SPRINGFIELD'S *Celebrated* HORSESHOE SANDWICH

Carolyn Harmon & Tony Leone

AMERICAN PALATE

Published by American Palate
A Division of The History Press
Charleston, SC
www.historypress.com

Copyright © 2019 by Carolyn Harmon and Tony Leone
All rights reserved

First published 2019

Manufactured in the United States

ISBN 9781467139885

Library of Congress Control Number: 2019932630

CONTENTS

ACKNOWLEDGEMENTS

We would like to thank Curtis Mann, the manager of the Sangamon Valley Collection of Lincoln Library in Springfield, Illinois, and his assistant, Stephanie Martin. Tara McAndrew has provided support and editorial assistance. The family of Joseph Schweska, including Jan Mitello and Betty Willis, helped clarify horseshoe and family history and provided family photos. Angie Powell, a great-granddaughter of Joe Schweska, provided a horseshoe story. Joseph Schweska, a grandson, has also shared memorabilia. Lou Allyn Byus, the daughter of Wayne Coumbes, shared insights into her family's contribution to the horseshoe legacy and family photos. Verney Blackburn talked about his experience at John's Lounge. Joe Rupnik shared his family's horseshoe history, including why he says the Dublin Pub has the "original" recipe. Several people granted permission to print their recipes and use their photos.

INTRODUCTION

he horseshoe sandwich is a Springfield, Illinois culinary creation. Thanks to recent national publicity, more people are trying this unusual delicacy. The *Wall Street Journal* (2010), the *New York Times* (2006), the *Washington Post* (2016) and the *Chicago Tribune* (1983) had articles about horseshoes. *Gourmet* magazine featured horseshoes in 2009. Burt Wolf on PBS (*Local Flavors*), Peter Segal (*Wait, Wait, Don't Tell Me*) and Ian Chillag on NPR (*Sandwich Mondays*) did features on horseshoes. Burt Wolf described horseshoes as Springfield's "most famous contribution to the world of food." Al Roker did a *Roker on the Road* segment about horseshoes in 2004. Horseshoes were featured on the Food Network in 2017 and 2011 (*Diners, Drive-Ins and Dives*). In 2011, *Man v. Food* also featured horseshoes. The Cooking Channel highlighted a pork tenderloin horseshoe when hosts visited the Illinois State Fair in an episode of *Carnival Eats*. The horseshoe sandwich was listed in *500 Things to Eat Before It's Too Late* where Jane and Michael Stern said horseshoes were "unbridled plebian opulence." The *Huffington Post* listed Springfield's horseshoes in "50 Cities Known for a Specific Food" in 2014.

Horseshoe sandwich history can be found at www.whatscookingamerica.net. There also are Facebook pages. "The Horseshoe" started about 2009 and has over 10,000 likes. The "Horseshoe Sandwich: The Signature Dish of Springfield" page started a year later in 2010 and has more than 8,000 likes. A "Pursuing the Horseshoe Sandwich" group began about 2016 and has about 300 members. There is a horseshoe "thread" in the "Memories

of Springfield" Facebook page. There is a blog about horseshoes from the "Horseshoe Quest 2011" at www.horseshoequest.blogspot.com.

In 2003, the State of Illinois was choosing an Illinois Official Snack. Although popcorn won, horseshoes were a close second according to an article in the *State Journal-Register*. They are even mentioned in the children's book *Goodnight, Springfield*. Articles have also appeared on websites such as www.americanfoodroots.com and www.businessinsider.com. Horseshoes were listed as something to experience in a "Springfield Trip Guide" and "A Two-day Getaway to Springfield, IL" by the editors of *Midwest Living* magazine at www.midwestliving.com. Stevie Zvereva "blazed" a horseshoe "trail" through Springfield in a *Peoria Magazines* article in 2014. She had breakfast horseshoes at Ritz's on North Grand and Charlie Parker's Diner. Next she visited Darcy's Pint, Boone's Saloon and Norb Andy's. Horseshoes were also mentioned on WGN radio during a Cubs game in 2008 in a "What's Local to You" segment.

Horseshoes have been discussed in many articles in Springfield magazines and newspapers. Horseshoes were featured at a "Road Food Symposium" sponsored by Greater Midwest Foodways in the Chicago area in 2012 after Julianne Glatz's article was published in the *Illinois Times* earlier that year. Glatz presented "Whatever Happened to the Horseshoe?" at the symposium and was also interviewed on Chicago radio station WBEZ about her presentation. Small horseshoes were part of the lunch. Glatz called them "horseshoe sliders" in an *Illinois Times* article about the symposium.

Horseshoes are appearing on menus in distant cities, such as Austin, Texas, and Atlanta, Georgia. In an interview with Jay Fitzgerald in 1986, Bob Perry claimed he even took the horseshoe to the Tivoli Guest House in Panama. You can find horseshoes in Chicago and the St. Louis area. The *Riverfront Times* did an article on a Horseshoe contest between the Horseshoe House in St. Louis and the Belleville Moore's Restaurant in 2011. Sadly, the Horseshoe House has closed. There are places for a horseshoe fix just across the river. The place in Belleville is still open along with restaurants in Collinsville, Edwardsville and Hamel that serve horseshoes.

Horseshoes have even made it to the ballpark. A post by Ashok Selvam on the www.chicagoeater.com website says that the Chicago White Sox had horseshoes for the first time in 2018. The Sox's "South Side Horseshoe" has Italian sausage, giardiniera (Italian pickled vegetables) and the usual fries on "thick-cut" garlic Texas toast. The cheese sauce uses Modelo beer (the official beer of the Sox). Created by Levy Restaurants, the sandwich is only available in "premium seating." The "South Side Horseshoe" was on the

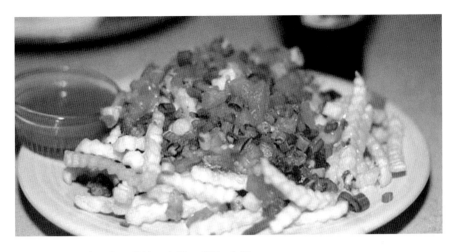

A typical horseshoe from D'Arcy's Pint. *D'Arcy's Pint.*

menu for the MLB Food Fest in April 2018 in New York City. This is where each major league team features one food item.

So what exactly is a horseshoe? It usually starts with a bread base. Then meat is added with French fries placed on the top. The crucial element is the cheese sauce, which is sometimes put on before the fries, while others put it on the top. More versions have been created over the years. Several restaurants have breakfast 'shoes, and a few people have created dessert 'shoes. The meat portion has been modified with all sorts of interesting things, including vegetables or veggie burgers. Since horseshoes pack a wallop, a smaller version is usually available and called a pony 'shoe (sometimes called the wimpy 'shoe). A food truck vendor created a "walking pony 'shoe." There is even a "Horseshoe Spoon" appetizer and a horseshoe pizza.

Horseshoes are different from other regional dishes. The Southeastern Hot Hamburger Plate has bread, hamburger, fries and maybe a cheese slice but uses brown gravy. The Louisville Hot Brown was created in the 1920s. It uses a Mornay cheese sauce but does not have French fries. The St. Louis Slinger uses hash browns and grated cheese. The New York Garbage Plate was created about 1918. It does not have cheese sauce and has macaroni and bread on the side. The poutine began in the 1950s in Quebec but has now expanded to most of Canada. It has cheese curds and light brown gravy. A breakfast horseshoe might use hash browns and sausage gravy, which blurs the lines. The key to a traditional horseshoe is the cheese sauce. Any chef will tell you that. (Only the horseshoe and hot brown are listed in *The Encyclopedia of American Food and Drink*.)

Horseshoes are adaptable. Although the original was typical "American" food of French fries, ham and bread, many other versions have been created. There are even international horseshoes with Mexican, Italian and Greek/Mediterranean influences.

The horseshoe has appeared on several best sandwich lists, including "A Field Guide to 20 Great Regional Sandwiches of the USA" from Lonely Planet in 2012. It was also listed in the September 2014 *Esquire* "United States of Sandwiches" issue and the November 3, 2013 *Business Insider*'s "50 Most Famous Sandwiches Across America." Alvin Ward calls the horseshoe one of the best sandwiches in a *Mental Floss* article from April 2015. Jeff Mauro has a recipe for a Grilled Ham and Beerbit Horseshoe in a *Sandwich King* episode called "Indulgent Bites," which aired on the Food Channel in 2013. Jeff also created a hot turkey horseshoe sandwich for a "money-saving madness" episode of *The Kitchen* on the Food Network in January 2019. The horseshoe is usually called a "horseshoe sandwich."

But is it really a sandwich? Most definitions of a sandwich involve two slices of bread with something "sandwiched" in between. We know the Earl of Sandwich creation in 1762 followed this approach. There was even a court case in 2006 in which the legal definition is a "traditional" sandwich according to a 2014 article in *Atlantic*. In the same article, the state of New York was considered to have a more inclusive view of sandwiches that includes burritos. *Mental Floss* provided "5 Ways to Define a Sandwich, According to the Law" in 2017. Open-faced sandwiches have been around for centuries. Many countries have a version. They are especially popular in Scandinavia. In Great Britain, cheese on toast might be an open sandwich according to the *Oxford Dictionary*. In the United States, an open-faced sandwich can include hot roast beef or chicken on bread with mashed potatoes and gravy. Although some menus have the horseshoe listed as a sandwich, many put them in a separate category like entrée. Michael Stern called the horseshoe a "pseudo-sandwich" in his www.roadfood.com review of Ritz's breakfast horseshoe. Jim at www.sandwichtribunal.com weighed in on the sandwich question. Horseshoes were included, but he noted that they might be more appropriately considered an entrée.

The book *You Know You're in Illinois When…* describes "a horseshoe as a dining delicacy." Back in 1947, a *Saturday Evening Post* article by Elise Morrow described the horseshoe sandwich as "an indigestible but satisfying collection of toast, fried egg, ham and French-fried potatoes, covered with a thick, rich Welsh rarebit and served on a sizzling oval platter."

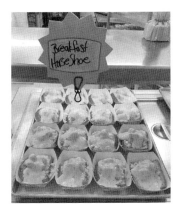

Springfield Public School District breakfast horseshoes. *Springfield School District Food Service.*

LTH Forum, a "Chicago food chat" website had a post and thread about horseshoes in 2012. It started with information about Julianne Glatz's *Illinois Times* article, and several people posted information about other places that serve 'shoes. There was a discussion about a "Splendid Table" post that said horseshoes came from Springfield, MISSOURI. A thread about "Springfield" in 2010 mentioned a D&J breakfast horseshoe and Westwoods Pub. In 2005, there was a lengthy discussion about Springfield visits that included a person's favorite 'shoe and a review of the Coney Island hamburger pony 'shoe.

Horseshoes have been on the lunch menu in the Springfield, Illinois public school district for about fifteen years. The school district added a breakfast horseshoe in 2017. They have also been seen for lunch in Rochester, Illinois schools.

Horseshoes have a controversial history. Local newspaper and magazine articles have created some confusion about who created the horseshoe. The creator(s) and the people who made sure horseshoes stayed on the menu are recognized in chapter 1. A look at the intertwined history of Route 66 and horseshoes is also included.

At least seventy local Springfield restaurants have served horseshoes over the years. While a few restaurants have closed, more than fifty are still serving some version. Local "Horseshoe Showcase" tastings and contests have been offered by various groups over the years. Judges or attendees vote for the best horseshoe in various categories. During one of these, a controversy arose and the winning restaurant was disqualified. The daily and weekly newspapers let subscribers vote on the Best of Springfield (*Illinois Times*) or Reader's Choice (*State Journal-Register*). Usually, horseshoes are included. Many restaurants have framed "best of" award certificates on their walls. One restaurant created a record-breaking horseshoe in 2013. Chapter 2 summarizes the best and the biggest 'shoes.

Chapter 3 provides a trip down memory lane. Restaurants that served horseshoes and no longer exist are reviewed. Chapter 4 takes a look at current restaurants that serve horseshoes. Some of these restaurants also have a long history. The restaurants that have connections with Route 66 and other historical events and people are identified.

Chapter 5 looks at where the horseshoe has gone. From central Illinois towns to larger midwestern cities, the horseshoe is on the move. A few restaurants a long distance from Springfield provide horseshoes for people who want them without having to drive to central Illinois. Most of the expansion is by former Springfield residents who have carried the horseshoe to new locales. A 2002 article in the *State Journal-Register* indicated that Corky's Ribs & BBQ planned to expand horseshoes to other locations besides Springfield. Corky's in Springfield was closed by 2008, and horseshoes are not on the national menu.

The original creator, Joe Schweska, was willing to share his cheese sauce recipe. Over the years, chefs have been more protective of their formulations. Several recipes are provided in the appendix, including revisions to the recipe to make the horseshoe healthier. Horseshoe recipes can be found in several books.

You can use the restaurant information to create your own "Horseshoe Adventure." In 2011, a couple of guys named Evan and Kevin started a Horseshoe Quest blog (horseshoequestblogspot.com). They chose fifteen restaurants to visit and evaluated their horseshoes. Their rating system included cheese, meat and fries. (Cheese would of course be cheese sauce.) They also supplied commentary about each restaurant/horseshoe. They added a new restaurant at the last minute, so the total was sixteen. They provided winners in the following categories: best surprise, best traditional, best unique, best new, best cheese, best meat, best fries, best overall and best horseshoe restaurant. The restaurants they chose are included in the restaurant section of this book. You can read their reviews and see photos of each restaurant's horseshoe. The ones that have closed since 2011 are discussed in the "Memory Lane" chapter.

CONTROVERSY ABOUT THE HISTORY AND ROUTE 66

*T*he Springfield newspaper, the *State Journal-Register*, has had many articles about horseshoes over the years. Some of them have sparked controversy about how the horseshoe was developed. Steve Tomko's interviews in 1986, 1979 and 1972 gave him the credit along with Joe Schweska. Steve was a teenage kitchen helper when the horseshoe was created. Tony Wables was another teenager who said he was helping in the kitchen at that time in a 1980 article. Other names mentioned in various articles include John Danko, John Rupnik Jr., Ray Logue, Ray Kyle, Bob Houston, Augie (August) Schilling and Wayne Coumbes. There will be more about them later. Comments by people in interviews and letters to the editor of the *State Journal-Register* make the history clear. The Leland Hotel was the location of the horseshoe's creation, and Joe Schweska was the creator. Steve Tomko does deserve credit for carrying on the horseshoe in his restaurants and Wayne's Red Coach Inn.

The Leland Hotel, Where the Horseshoe Was Created

The first Leland Hotel opened on New Year's Eve 1866. It was named for Horace Leland, who was the first host, or manager. The original Leland

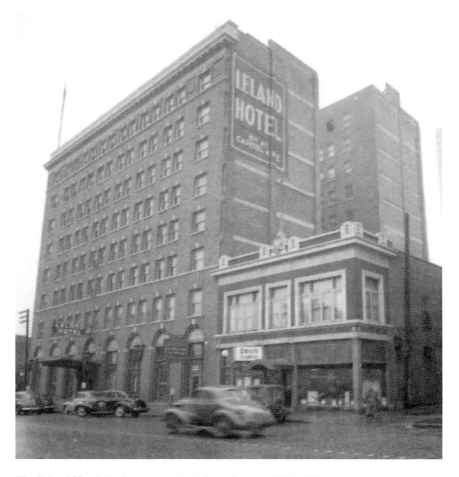

The Leland Hotel, the horseshoe's birthplace. *Sangamon Valley Collection.*

Hotel was described as "one of the striking landmarks in the western hotel world" in the *Illinois State Journal* in 1896. Many famous people, including prominent Republicans, were guests of the first hotel. After a fire in 1908, a group of Springfield leaders realized how important the Leland was to the city and the capitol. A year after the fire, they created the Springfield Hotel Company through the Springfield Chamber of Commerce. This "stock company" allowed the group to raise money to build a new hotel. Articles in the local newspapers followed the progress of the new construction.

Members of the Bunn, Reisch, Hay and Ridgely families held considerable amounts of stock. Prominent women like Alice E. Ferguson and Mrs. George Chatterton Sr. also held stock. Chief among the stockholders were

Dr. George Pasfield and his son, George Pasfield Jr., who was unanimously elected the president of the Springfield Hotel Company. He supervised the hotel's construction and development. The Chicago architectural firm of Holabird and Roche was selected to design the new structure. Culver Construction Company was contracted to build the new hotel, while the world-famous Tiffany & Co. created interior details.

The new building was completed in 1911, with many articles about the opening. George continued to guide the hotel until 1926, while the Perry-Rigby Hotel Company was appointed the manager of the hotel. Edward O. Perry was the president of the Perry-Rigby Hotel Company, while Captain Edward S. Perry, Edward's son, was the vice president. George Pasfield Jr. continued as a director until 1929, at which point the hotel was in the hands of the Perrys. They continued to manage the Leland until 1947. They were owner/managers, while George Pasfield Jr. was still on the board when the horseshoe was created.

In 1928, Joe Schweska, the Leland Hotel chef, was looking for a new dish to add to the lunch menu. According to his granddaughter, Jan Militello, he had leftover Easter ham. His wife, Elizabeth, found a recipe in one of her cookbooks for Welsh rarebit sauce, and they came up with the original idea. (Welsh rarebit sauce is a British dish of melted cheese blended with beer and seasonings served over toast.) According to some people, the name *horseshoe* originated from the shape of a bone-in ham slice. A daughter, Jackie, said the name came from the shape of the potato wedges, which

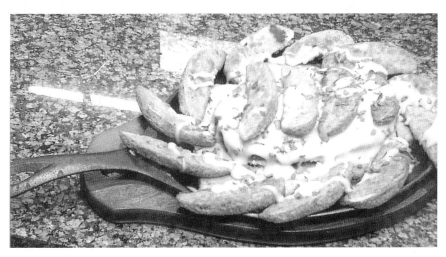

An "original" horseshoe. *Tony Leone.*

were cut lengthwise and placed around three sides of the ham to resemble a horseshoe. A hot platter was supposed to resemble the anvil. Some people say the potato wedges were the nails. The cheese sauce was poured over the meat and bread and the potato was put on the sides. Julianne Glatz, a food writer for the *Illinois Times*, described the early horseshoes at the Leland Hotel as "elegant," just like the hotel in a 2012 article.

(In a 1938 article in the *Illinois State Journal*, Joe Schweska shared his cheese sauce recipe. He said he had been serving horseshoes for six years, which would have made the creation closer to 1932. Every other reference indicates about 1928.)

Bob Perry was one of the letter-to-the-editor writers regarding the correct horseshoe story. He believed his father, Edward S. Perry, a co-owner of the Leland Hotel, also deserved some recognition. A 1986 *State Journal-Register* article credited Edward S. Perry and his father, Edward O. Perry, the other Leland Hotel owner, with a contribution to the horseshoe's development. In the same article, Joe Schweska Jr. felt his mother, Elizabeth, should have been given more credit.

Edward O. Perry died in 1934. His wife, Gertrude, was one of the people participating in the 1947 sale. Edward S. Perry; his wife, Eleanor; and his sister Lucille Perry Biggerstaff were the other people involved. Captain Edward Stark Perry died in 1953.

The Leland Hotel had "numerous dining and coffee rooms," including a "sun parlor," according to articles in the *Daily Illinois State Journal* and *Daily Illinois State Register* from the opening in 1911. In 1936, there was a tavern, coffee shop and dining room. The Flamingo Room and a ballroom were mentioned. The Flamingo Room was also mentioned in 1942. The Sunbrella was mentioned in 1952 and 1954. A 1952 ad for the "Hotel Leland" in the *Illinois State Journal and Register* had drawings of John Rupnik, chef; Ann Casper, hostess of the Coffee Shop; and Dorothy Tweedel, hostess of the Tavern Room. There were no mentions of horseshoes because they were "a special item" not listed on the menu of the Sunbrella, according to Joe Rupnik, John's son.

The Red Lion Tavern did not open until 1956. The Red Lion was famous for horseshoes. The Leland manager at the time was Jim Bolinger. (When some people from Springfield visited Bolinger's Supper Club near Pipestem, West Virginia, in 1993, they found a "horseshoe platter" on the menu and asked about it. Bolinger claimed he "introduced" the horseshoe when Toby McDaniel wrote a column about the visit in 1993. Trice D. Yemm wrote a letter to the editor in response to Bolinger's claim stating that McDaniel was

"misinformed.") Joe Rupnik said that his father, John, was the chef when the Red Lion opened. He was the one who added the horseshoe variations and French fries and put it on the menu. Until that time, the horseshoe was the "original" ham and potato wedges. Jim Bolinger was the manager, so he could take some credit for putting the horseshoe on the menu.

John Rupnik Jr. died in 1990. Born in 1916, his obituary stated he was an executive chef at the Leland Hotel for twenty-nine years before retiring in 1961. His son, Joe, said his father started at the Leland in 1932 and left in 1960 to go to the Holiday Inn restaurant.

The Sangamon County Historical Society's *Sangamon Link* tells about the Leland Hotel's six-hundred-acre farm, which supplied much of the food for the hotel. The area is now Leland Grove and Oak Knolls.

The old English-themed restaurant finally closed in 1970, about the same time as the hotel, which had become the Leland Motor Hotel in 1965. Bolinger was the manager from 1948 until 1969. People were supposedly eating horseshoes when the power was turned off to the restaurant. There was some hope of the hotel reopening in 1971, but the building was eventually sold and was used by Sangamon State University and now houses the Illinois Commerce Commission.

Many famous people visited the Leland Hotel, including members of the Republican Party. Historic events like the Illinois Constitutional Convention in 1970 also took place there.

Joe and Elizabeth Schweska

As mentioned, Joe was the chef at the Leland Hotel in 1928. He and his wife, Elizabeth, had been living in Springfield for a while. He was born in 1901, so he was about twenty-seven years old when he created the horseshoe. He immigrated to the United States in 1903.

Joe married Elizabeth Timlick in 1919 in Missouri. Elizabeth was born in Cantrall, Illinois, near Springfield in 1900. She and Joe were close to the same age. They were living in St. Louis in 1920, and he worked in a restaurant according to the Census. By 1924, the family was listed in the Springfield City Directory, and their son Joseph Jr. was born in Springfield in 1921. By the 1930 Census, they had five children: three daughters and two sons. By 1940, they had one more son, six children total. Elizabeth stayed home to take care of their family while Joe worked. According to

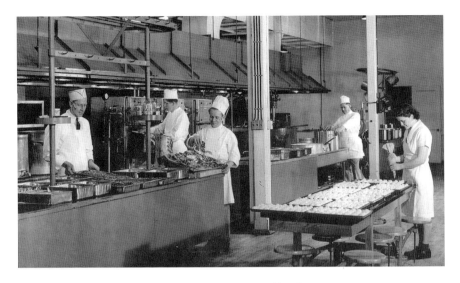

Joe Schweska and assistants in the kitchen. *Betty Willis/Tony Leone.*

the Census, he worked about sixty-five hours per week and they still lived in Springfield.

Joe moved his family to Decatur, Illinois, in the 1940s to work as a chef at the Caterpillar Defense Plant. Although he was too old to enlist, he wanted to do his part in the war effort, according to Jan Mitello. Elizabeth also worked in the plant. By 1948, they were back in Springfield, and he worked at the Mill Restaurant until about 1952, when the family moved west due to Elizabeth's health issues. First, they lived in Arizona. Elizabeth was mentioned as living in Tucson in a 1954 obituary for a family member. According to Joe Jr., they brought the horseshoe to Tucson. Betty Willis, Joe's daughter, said Joe worked at a golf course food concession. (There is currently one restaurant in Tucson with horseshoes on the menu.)

The family eventually moved to the Pasadena, California area, where Joe worked at a cafeteria called Beadles. They celebrated their fiftieth wedding anniversary at their daughter Betty's in Wheat Ridge, Colorado. All six of their children were there when they renewed their vows. When Joe died in Temple City, California, in 1971, they had twenty-eight grandchildren and seven great-grandchildren. According to the obituary, their daughter Jacklyn was living near Decatur, Illinois, and a son, Al, was living in California. Their son Joseph Schweska Jr. was living in Springfield. Elizabeth died in 1972 in Wheat Ridge, Colorado, where daughter Betty lived. Another daughter, Helen, lived in Beaverton, Oregon.

The Schweska fiftieth wedding anniversary with all six children in 1969. *Betty Willis*.

A great-grandson went to culinary school and works in the food industry. A great-granddaughter, Angie Powell, and her future husband had horseshoes on their first date. When she told him her great-grandfather invented the horseshoe, he didn't believe her. They celebrate their first date anniversary each year with horseshoes.

The Schweska family horseshoe recipe is in the appendix.

George Pasfield Jr.

George Jr. was involved in many Springfield businesses. He took over the management of the family finances when his father, Dr. George Pasfield, died in 1916.

George Jr. was born in Springfield in 1870. He and his wife, Caroline Merritt Pasfield, had two daughters. Caroline died in 1924. He remarried right before his death in 1930 at the age of sixty. He died from heart disease, which some people attributed to horseshoe consumption. Daughter Charlotte had two children, Robert Vroom and Charlotte Vroom Stuckey. Charlotte died in 1982. Daughter Susan had two children, Stephen Bartholf and Carolyn Barholf Oxtoby. Susan died in 1991. Carolyn Oxtoby is a well-known Springfield preservationist and downtown landowner. She has been instrumental in keeping Maldaner's Restaurant open.

The Pasfield House and Tony Leone

The history of the Leland Hotel and the Pasfield House are intertwined. Patrick Pospisek researched the history of the house for a landmark petition. A summary is available at the Pasfield House Inn's website: www.pasfieldhouse.com.

George Pasfield Jr. built a house for his family at the corner of Jackson and Pasfield Streets in 1896. This was at the entrance to the family estate. After his death in 1930, his daughter Susan Pasfield Barholf and her family moved in. About 1939, they built a house in Leland Grove. The Pasfield house was sold and divided into apartments. The house was purchased by Springfield businessman Tony Leone in the 1990s. He restored the house, which is now the Pasfield House Inn Bed and Breakfast. Located at 525 South Pasfield Street, the Pasfield House is just a block away from the Illinois State Capitol. The house is a city landmark.

Tony Leone is Springfield's horseshoe expert. Julianne Glatz appreciated all the assistance he provided when she wrote her article for the *Illinois Times* in 2012. Tony's résumé includes membership on the Illinois State Capitol Historic Preservation Advisory Board and a trustee of the Illinois Historic Preservation Board. He was named the 2011 Preservationist of the Year, when he won the Springfield Mayor's Award for Historic Preservation for his work on the Pasfield House. He became a horseshoe expert when researching the history of George Pasfield Jr. As mentioned, George was the president of the Springfield Hotel Company, which initially raised $125, 000 to build a new Leland Hotel. According to a 1911 article in the *Illinois State Register*, the capital stock was increased to $175,000 by the time the hotel was built.

Tony has provided information about the Pasfield family, the Leland Hotel and horseshoes to historians. He has also done presentations for various groups, including the Sangamon County Historical Society. His letter to the editor of the *State Journal-Register* on August 4, 2009, clarified the correct history of the horseshoe's creation. He has been interviewed for the *Wall Street Journal* article in 2010 and a Michleen Collins article in 2010 from www.michleen-collins.com.

The Pasfield House Inn competed in the 2009 World Horseshoe Cook-off. It won the Breakfast Horseshoe category. Although horseshoes are not usually on the breakfast menu, the egg strata that was part of the creation is. A photo of this horseshoe, with the components identified, was included in the *Wall Street Journal* article.

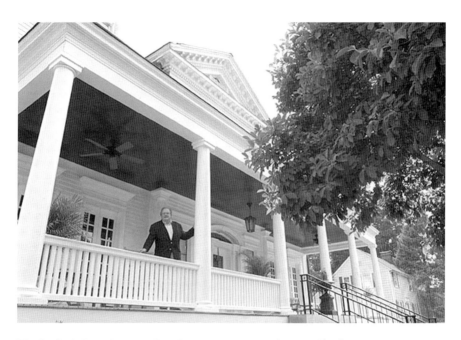

The Pasfield House Inn and Tony Leone, innkeeper and owner. *Tony Leone.*

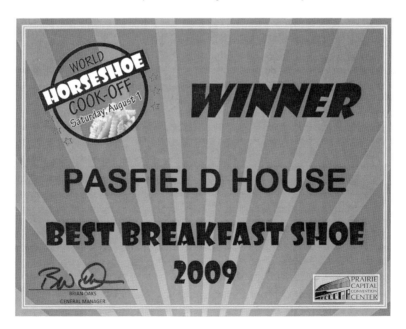

Winning certificate from 2009 Horseshoe Cook-Off. *Tony Leone.*

Tony Leone explains how the Egg Strata was transformed into a horseshoe:

The Egg Strata sits on a slice of smoked prime cured ham instead of toast. A meat item usually sits upon the toast; we reverse that order so the ham stays hot after being grilled in butter on the metal serving platter. With our version, the bread component lies within the Egg Strata, using buttery croissants. Usual horseshoe sandwiches are topped with French fries. Keeping with the original creation, baked potato wedges are used instead with an authentic Welsh Rarebit cheddar cheese sauce. Our juxtaposition on the 1928 Leland Hotel original horseshoe makes for an elegant dish at breakfast or anytime.

Steve Tomko, John Semanik and John's Lounge

Research indicates that by 1946, Steve Tomko had a restaurant called Steve & Don's; it became Steve & Lee's about 1956. The building was then sold to John Semanik about 1962 and became John's Lounge. John kept Steve on as chef. Horseshoes were offered at all three places thanks to Steve. Verney Blackburn worked at John's Lounge as a teenager. In a phone interview, he said that Steve would make the cheese sauce, and then another cook named Charlotte (John's sister) would add A1 Steak Sauce. John's Lounge was a very popular place. They made gallons of cheese sauce every day. John Semanik may have later worked at Edgewood Country Club in Auburn,

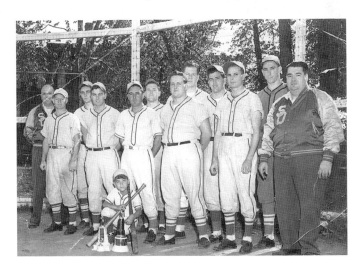

Steve Tomko (*far right*), manager of Steve & Don's softball team, 1949. *Carol Gillespie Forestier.*

Illinois. Verney said that John would have staff over to his house, and a person on Facebook said John was a nice person.

Wayne Coumbes and a couple of partners purchased John's Lounge in about 1969. Prior to the purchase, Wayne worked at John's Lounge with John Semanik and Frank Kohorst. This would have been a couple of years before opening Wayne's Red Coach Inn. Before his death in 1990, Steve Tomko was able to tell his story of the horseshoe creation multiple times. Steve does need to receive credit for carrying on the horseshoe after Joe and Elizabeth Schweska moved away. Steve has been credited with carrying the horseshoe to Wayne's Red Coach Inn, where its popularity increased. Steve was only at Wayne's Red Coach a few years before he retired in 1973. He received a plaque about his involvement with the horseshoe creation.

Wayne Coumbes, Wayne's Red Coach Inn

As mentioned, Wayne and Steve worked together at John's Lounge. Wayne also worked at the Leland Hotel before going to John's Lounge, according to his daughter, Lou Allyn Byus. Wayne sold his interest in John's Lounge and opened his Red Coach Inn at the corner of North Grand and Rutledge Street in 1971. After his death in 1990, his wife, Bertie, and family kept the restaurant open until 2002, a total of thirty-two years. They continued to serve the original horseshoe sandwich, using the original recipe the entire time. Wayne and Bertie's oldest grandson, Jeremy Wayne Coumbes, was the last family member to work at the Red Coach, according to

Top: Plaque given to Steve Tomko on his retirement from Wayne's Red Coach Inn in 1973. *Lou Allyn Byus.*

Bottom: Wayne and Bertie Coumbes, owners of Wayne's Red Coach Inn. *Lou Allyn Byus.*

daughter Lou Allyn. He was a busboy in high school and a floor manager when he was in college. Many people thought the Red Coach's horseshoes were the best. Kurt Ritz said he got his horseshoe recipe from Wayne in various interviews, including one on www.whatscookingamerica.net. He worked at the Red Coach before opening Ritz's Lil Fryer and the second Ritz's location.

John Rupnik Jr. and Family

John Rupnik's four sons continued his food service legacy. Joe owns the Dublin Pub, which he says has the original horseshoe cheese sauce, thanks to his father, the Leland Hotel chef. Joe also owned Vic's Pizza (now closed), which served horseshoes while he was the owner. Before that, Joe was a manager at the local Steak 'n Shake for eleven years. His children Mark and Lee have helped manage his restaurants. Joe also co-owned Uncle John's Family Restaurant in Edinburg with his brother John for about six years. Gene owns some IHOP restaurants in Springfield with his son. Michael was a restaurant manager when he died in 2005. Joe's mother, Marian Rupnik, also worked in the food service industry. She was a waitress and then a manager at the Glade Room in the St. Nicholas Hotel.

What Happened to the Other Young People Who Worked at the Leland Hotel?

Tony Wables was born in 1910. He said he was at the horseshoe's creation in a 1980 article. He worked at the Leland Hotel for sixteen years, the Mill for twenty-six years and the Holiday Inn East for fourteen years before retiring at eighty-three according to his obituary in 1993. A 1972 ad for the Mill restaurant gave a discount for its horseshoe to honor chef Tony Wables for his part in perfecting the original horseshoe sandwich. John Danko was born in 1925 and was listed as a chef at the St. Nicholas Hotel in 1948. A sister worked at the Leland Hotel at that time. His obituary said he worked at the Leland Hotel for twenty years, the Mansion View and the Holiday Inn South and Holiday Inn East for twenty years. Many Springfield restaurants, including the Mill, the Mansion View and the Holiday Inn East, had horseshoes on the menu

thanks to these men. Steve Tomko or another Leland chef also added the horseshoe to the menu of Norb Andy's Tabarin. (Norb Andy's was across the street from the Leland.) When the Leland Hotel closed in 1970, five horseshoe sandwiches were the last food served, according to John Danko in several articles. Augie (August) Schilling was mentioned in a 1946 article from the *Illinois State Journal and Register*. He was the head chef at the Leland but was hospitalized, so Ross Dunlevy took over as chef. Other members of the Leland kitchen staff were John Danko, Clarence Van Wert, Francis Yeaman and Lloyd Clark. When he died in 1965 at the age of fifty-six, Augie was the head chef at the Mill.

Other chefs who got their start at the Leland Hotel include Ray Logue and Bob Houston. Ray was interviewed in the Gonko article in 1979 when he was the chef at the Holiday Inn South. His cheese sauce recipe was included in the article. He worked at Viola's Tavern in 1967. He was the chef at the VFW in 1980 and opened the Glass Terrace at Capital Airport in 1983. When he died at the age of sixty-seven in 2007, Bob Houston said in a tribute that he and Ray worked together at the Leland Hotel. Bob was a chef for forty-eight years at the Leland Hotel, the Caucus Room of the Lincoln Towers and the Fairview Tavern, according to his obituary in 2013. They took the horseshoe with them to their other restaurants.

Denny Joslin, in an article about the Beef 'n Brew Restaurant in 1984, said he got his horseshoe recipe from Ray Kyle. Ray Kyle was born in 1918, so he would have been at the Leland later. His 1988 obituary said he was a chef. An article in a 1969 *Southern Illinoisan* said that Charles Butcher also was a chef at the Leland Hotel before becoming executive chef for some Ramada hotels in southern Illinois. He continued the horseshoe tradition in those restaurants.

Different Ideas about Cheese Sauce

Rabbit or rarebit sauce also has a disputed history. Welsh rabbit in 1725 differs from Welsh rarebit in 1785, according to *British Heritage* (April-May, 1998). Both seem to be the result of food scarcity. Rabbit might have been a sarcastic comment about the lack of meat, while "rarebit" was about stretching a rare bit of cheese. The definition in *Merriam-Webster* asserts that Welsh rabbit is melted, often seasoned, cheese poured over toast or crackers. This is similar to the *Oxford Dictionary* definition.

Steve Tomko reiterated that the original cheese sauce did not have beer or near beer, while Tony Wables Sr. insisted that near beer was in the original recipe in a 1986 *State Journal-Register* article. The near beer was thanks to Prohibition. Tomko and Wayne Coumbs stressed that their cheese sauce did not have beer.

In the same article, Mary Bailie said she used Rhine wine in her Norb Andy's cheese sauce. The rest of the ingredients were a secret. Gabe Chiaro said he used a combination of the Red Coach and Norb Andy's sauces at the Horseshoe Pub. He wouldn't say how he obtained the formulations and was not willing to share his.

When Joe Schweska's granddaughter asked him how to make cheese sauce smooth, he told her to use a wooden spoon. She says that it works.

New variations of cheese sauce have been created over the years. A *Wall Street Journal* article says that D'Arcy's Pint started the white cheese sauce choice in 1998. In a 2002 *State Journal-Register* article, Tommy Cerri, a manager at Coney Island, said that he began using a white cheese sauce about 1991 when he was at Chatter's in Chatham, Illinois. He said he made the sauce with a combination of white cheese, 2 percent milk, Tabasco and Worcestershire sauce. "I think it's a lighter, fluffier sauce." One person recommended easy cheese sauce for her family with Velveeta and milk. Many people think Old English cheese sauce is crucial. Others think it's the beer they add. Some restaurants began making their horseshoe cheese sauce with Springfield's historic Reisch beer when it was re-released in the spring of 2019.

Collin Smith was the chef at Norb Andy's when Stevie Zvereva asked him about his cheese sauce in 2014 for her "Follow That Horse…Shoe" article. He said he used both white and yellow cheddar, beer, cayenne pepper, salt and pepper. In that same article, the folks at Boone's Saloon said they also used both white and yellow cheese and a "secret blend of spices." Mike Murphy, from Charlie Parker's Diner, said he used processed cheddar cheese, Worcestershire and hot sauce, but no beer.

One other distinction is needed. The cheese sauce used for horseshoes is similar to fondue cheese sauce. Usually, wine is added to fondue cheese sauce and lighter cheeses are used, but some people have made "Welsh Rarebit Fondue." The British newspaper the *Telegraph* published a recipe for Welsh Rarebit Fondue in 2012. Some people have called Welsh Rarebit "English fondue." When modifications are made to traditional horseshoe cheese sauce, like adding wine, the line is blurred. A local fondue restaurant served horseshoes. Some Mexican horseshoes have queso cheese sauce. Jim

discussed cheese sauce at www.sandwichtribunal.com while he examined horseshoes he and his friends tried at Darcy's Pint. He distinguished between Mornay sauce and Welsh rarebit, suggesting that Mornay is more of a white sauce. Many places have a yellow and a white cheese sauce choice, including Darcy's Pint and Dublin Pub.

Sarah Lopinski, a dietician with Prairie Heart Institute, developed a "Prairie 'Shoe" with healthier cheese sauce and baked fries for Norb Andy's. Sadly, it didn't last very long on the menu. There are ways to make the horseshoe healthier and even vegetarian or vegan. Avocado can even be added to the cheese sauce.

When asked what makes their horseshoes special, most chefs will say the cheese sauce, which they each try to make a little bit different. Michael Stern of www.roadfood.com discovered that beer is often not included in the cheese sauce but suggests that "Springfield's better sauces have a hopsy verve that balances their thickness and offers contrast to the heft of potatoes above and meat below." Besides beer, ingredients can include egg yolks, butter, Worcestershire sauce, cheddar cheese and a variety of spices. Thomas Joseph provides a video about the science behind a perfect cheese sauce in "Kitchen Conundrums" at www.marthastewart. com. Another option is frozen Stouffer's Welsh Rarebit. It tastes like authentic cheese sauce.

Another Cheese Sauce Question

One other source of discussion is whether the cheese sauce goes over the top of the whole thing or if the cheese sauce is put on before the fries. Traditionalists believe the fries go on top of the cheese sauce.

Route 66

Route 66 began about the same time as horseshoes. Several historic restaurants that served horseshoes were on Route 66. Some of them have closed, but a few are still open. Many current restaurants on Route 66 serve horseshoes. The Route 66 Association has the "Where's Your Favorite Horseshoe?" on its Facebook page. The www.Route66guide.

Route 66 sign from Charlie Parker's. *Carolyn Harmon*.

com features Maid-Rite. It has horseshoes made from its steamed beef. *Diners, Drive-ins and Dives* on the Food Network stopped at Charlie Parker's Diner on a trip along Route 66. Horseshoes were on the menu. Burt Wolf's episode no. 104 of *Local Flavors* has Keith Sculle talking about the influence of automobiles and Route 66 in the development of Springfield, Illinois restaurants such as Maid-Rite. They visit Norb Andy's as part of his discussion of the history of horseshoes. The book by John Jakle and Keith Sculle, *Fast Food: Roadside Restaurants in the Automobile Age*, spends time discussing Route 66. Chapter 16 is devoted to "The Roadside Restaurant in Springfield, Illinois." Horseshoes are mentioned.

For people who want to "Get their kicks on Route 66" along with their horseshoe, the restaurants that serve 'shoes on or near Route 66 are identified. There are several in Springfield or very close by in towns like Sherman, Williamsville and Chatham. Many more restaurants, both north and south of Springfield in cities like Atlanta (Illinois), Pontiac, Bloomington-Normal, Carlinville, Virden and Staunton have also been identified.

There are several websites devoted to Route 66. Most cover the whole route through multiple states that do not have horseshoes. The www.illinoisroute66.org website provides a guide for just Illinois from the Illinois Route 66 Scenic Byway.

THE BEST AND BIGGEST HORSESHOES

here have been many events that highlight horseshoes over the years. This section will feature contests, tastings, "challenges" and unusual horseshoes.

Horseshoe Showcase/Taste of 'Shoes

In 1981, the first Horseshoe Cook-Off was held in conjunction with Lincolnfest, a Springfield summer festival. It was actually an international contest about the cheese sauce.

The Springfield IL Parks Foundation began a Horseshoe Showcase/Taste of 'Shoes in 1993. These continued for at least ten years. They were sometimes called cook-offs, since prizes were awarded. Several people organized these community events. The idea came from Patrick Londrigan, according to his wife, Ann, who was the chair of the second Horseshoe Showcase in 1994. Leslie Sgro, Park Board president, and her husband, Greg, were pictured helping at the event in an article from "The Springfield Limited Edition" of the *Decatur Herald & Review* in 1994.

In 1993, the first year of the Horseshoe Showcase, Baur's won Best of 'Shoe, Bernie and Bettie's won Golden 'Shoe and Steak 'n Shake won Honorable Mention. Other participants included Island Bay Yacht Club, Maldaner's and Norb Andy's.

In 1994, the Taste of 'Shoes competitors included Steak 'n Shake, which claimed to have the original cheese sauce recipe. It won a Preferred 'Shoe award along with Biloxi's. The Best of 'Shoe was awarded to Capitol City Brewing Company Bar and Grill for a traditional hamburger, ham or turkey horseshoe with beer-infused cheese sauce. The Trailblazer award for originality was given to Bernie & Betty's Pizza for its shrimp and tomato, fried chicken, Italian beef or vegetarian horseshoes. On Broadway's version with Louisiana kick thanks to Gloria Jenkins was the Big Cheese winner. Baur's won the Golden 'Shoe for the People's Choice. It added sautéed onions and peppers. Miss Kitty's Saloon won the No Small Fry for best fries. Six judges chose the winners, other than People's Choice.

In 1995, the Brewhaus's jerked pork or beef horseshoe with cheese sauce made from "premium" beers won the Big Cheese award. Gumbo YaYa's at the Springfield Hilton won the Presentation and Trailblazing awards for a shaved rib eye on French bread with wedges of baby new potatoes, Cajun étouffée and two kinds of cheese sauce. Chatters in Chatham won the People's Choice award for a breaded buffalo chicken 'shoe. Capitol City Brewing Company brought a traditional ham, hamburger or turkey 'shoe with cheese sauce made from its Australian ale. It won for best French fries. Baur's won the Best Horseshoe for a Philly cheesesteak 'shoe with pepper cheese sauce.

In 1996, Baur's, Island Bay Yacht Club, Chatters, Gumbo YaYa's, the Brewhaus and Yesterdays participated. The results were not available.

In 1997, Aunt Jean's Taste of Soul won the Best Overall Golden 'Shoe. A *State Journal-Register* article provided some insight into her secret sauce. She said she used "secret spices" and American cheese but no milk. Island Bay Yacht Club won the People's Choice, while Baur's won the Big Cheese and best overall presentation. Sunrise Café had the best fries and service, and the Brewhaus was the most innovative with pork in Jamaican jerk sauce.

In 1998, the Brewhaus won the People's Choice and best fries with a lemon garlic chicken horseshoe. Douger's won for the overall presentation. Norb Andy's won for the best sauce. Other participants included Island Bay Yacht Club, Sandwich Station and Sunrise Café, which won for fresh/fast.

In 2000, the following restaurants participated in the cook-off: Dippers, Norb Andy's, Island Bay Yacht Club, Vic's Pizza and the Sunrise Café. The results were not available.

In 2002, judges chose Coney Island as the Best 'Shoe. Maid-Rite Sandwich Shop won for the most original Trailblazer. The Barrel Head won the Big Cheese for its sauce. The Best Pitch for overall presentation went to Vic's

Pizza. The Office Tavern had the No Small Fry best fries. And the People's Choice Golden 'Shoe went to Norb Andy's Tabarin.

In 2004, so many people attended, they ran out of 'shoes. In a letter to the editor of the *State Journal-Register* November 1, the co-chairs apologized for running out. Barry Friedman also apologized in a November 6 letter. Norb Andy's ran out before the judging, but his Alamo restaurant won Overall Golden 'Shoe with its spicy Mexican cheese sauce. D'Arcy's Pint won the Trailblazer and People's Choice awards, Sportsman's Bar & Grill won the No Small Fry, Boone's Saloon won the Big Cheese, Corky's Ribs & BBQ won the Best Pitch for presentation. Other participants were the Barrel Head, Top Cats Chill & Grill, Suzie Q's and Country Club Saloon.

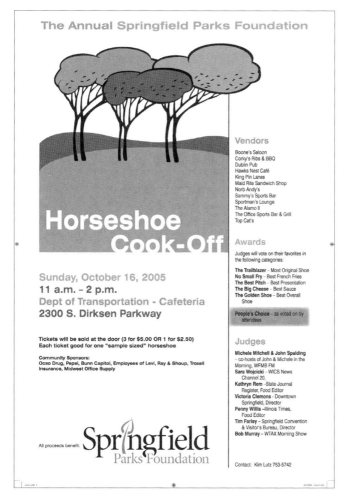

Springfield Parks Foundation Horseshoe Showcase poster from 2005. *Cathy Schwartz.*

In 2005, a crew of judges voted the Alamo II the most original (Trailblazer), Sportsman's Bar & Grill, the No Small Fry and Johnny's at King Pin Lanes the Best Pitch for presentation. Dublin Pub won the Big Cheese. Boone's Saloon won the Golden 'Shoe, and Top Cats Chill & Grill won the People's Choice Award. There is also a YouTube video of the 2005 horseshoe event from the local television station, WICS.

Best of Springfield

The *Illinois Times* weekly paper has conducted a Best of Springfield vote since 1984. Horseshoes have been included most of the years. People usually vote D'Arcy's Pint the best, with Dublin Pub often the runner-up. Other favorites have included Westwoods, Ritz's, Obed & Isaac's, Top Cats, Corner Pub and Grill and the new Keefner's.

The *State Journal-Register*, the daily paper, has had a Reader's Choice vote since 2008. The winners are also Darcy's Pint, with Dublin Pub, Ritz's, Westwoods, Burger Bar and the Corner Pub as runners-up. The *State Journal-Register* also allowed teen readers to vote for the Abe Awards starting about 2003. Horseshoes were sometimes included. Winners were usually about the same as the Best of Springfield and Reader's Choice awards. Abe's Hideout has been a runner-up for a few years. In a survey about the city's "biggest draw" in 2006, horseshoes won.

The Illinois State Fair Horseshoe Competition

The Illinois State Fair Horseshoe Competition was held in 2012 and 2013. Leslie and Greg Sgro sponsored the event and were the judges. An article in the *State Journal-Register* by Kathryn Rem in 2012 described "Creativity on display in state fair's first horseshoe contest." Dianna Ware won for a barbecue horseshoe of pulled pork and smoked turkey on cornbread with potato sticks and "homemade cheese sauce." Second place was a Tex-Mex 'shoe—a vegetarian option by Jessica Hatfield. Instead of meat, she had scrambled eggs and cornmeal-battered fried green chilies. Third was a buffalo chicken horseshoe with blue cheese sauce. A dessert horseshoe of French toast with caramelized bananas, apple slices and a white chocolate sauce

received Honorable Mention. Other entries were a Thanksgiving 'shoe with stuffing, whole-berry cranberry sauce, sweet potato fries and turkey gravy. A Reuben 'shoe was made of rye bread with corned beef, sauerkraut and Thousand Island dressing. The Scandinavian 'shoe was sourdough bread with red potatoes, smoked salmon and "dilled brie sauce." The other dessert 'shoe was a slice of walnut spice cake, brownie chunks, churro "fries" and mascarpone cheese sauce.

In 2013, the winner was the Spicy Horseshoe Sandwich by Peggy Wise of Springfield according to an article by Kathryn Rem in the *State Journal-Register*. The pork carnitas horseshoe used pepper jack and Monterey Jack cheese for the sauce and added pork cracklings. The recipe is in the appendix. Second place was "Shetland Sliders" with canapés of bacon, prosciutto, hash browns and an ale-based cheese sauce, which claimed to be the original Leland hotel sauce. Third place was a Shrimp Scampi Horseshoe: a Kaiser roll with cooked shrimp, tater tots and a mozzarella and Swiss cheese sauce. Other entries included the Bacon Bleu 'shoe, which used blue cheese, bacon and homemade potato chips on French bread. The Red, White and 'Shoe topped Texas toast with macaroni and cheese, fried pickles, diced jalapenos and fries. The Reuben had a sauce of Swiss cheese and beer, with corned beef, sauerkraut, fries and Thousand Island dressing on rye bread. One entry used portobello mushrooms, shrimp, wing sauce, pretzel bread and Guinness. Another entry used turkey burgers and fried green beans instead of French fries to make it healthier, although the Velveeta pepper jack cheese sauce still had some calories.

The St. Louis–Belleville Competition

The Horseshoe House of St. Louis competed with Moore's Restaurant of Belleville (across the river from St. Louis) for the best horseshoe on April 12, 2011, according to the *St. Louis Riverfront Times*. Moore's horseshoe was made from ground beef, fries, nacho cheese sauce and chili with Texas toast on the side. Adding fried eggs made it a "Slinger" horseshoe. (The Slinger is the St. Louis specialty of two eggs, hash browns, hamburger or other meat, covered in chili, topped with grated or shredded cheese and onions.) The Horseshoe House had traditional hamburger patties on Texas toast, fries and nacho cheese. Chili could be added. The writer said the Horseshoe House was better than Moore's but Moore's had "balance and flavor."

National Horseshoe Pitcher's Association and More Controversy

A World Horseshoe Cook-Off was held in conjunction with the 100th Annual World Horseshoe Tournament by the Horseshoe Pitchers Association in 2009 in Springfield. The cook-off categories were Classic, Breakfast, Dessert, Crazy Horse and Best Overall. Nine restaurants competed with sixteen entries. Lindsay's Restaurant initially won Best Breakfast 'Shoe, Best Overall 'Shoe and Best Crazy Horse 'Shoe. Since

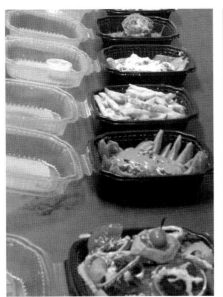

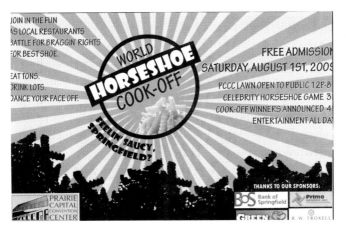

Above: 2009 World Horseshoe Cook-Off entries. *Prairie Capital Convention Center/BOS Center*.

Left: 2009 World Horseshoe Cook-Off poster. *Tony Leone*.

Lindsay's did not follow the rules and assembled its horseshoes in the restaurant's kitchen rather than at the Prairie Capital Convention Center (the location of the competition), it returned two of the awards. These were then given to Pasfield House for Best Breakfast 'Shoe and D'Arcy's Pint for Best Crazy Horse 'Shoe. Amber Jack Alehouse won for Best Dessert 'Shoe, and D'Arcy's Pint also had the Best Classic 'Shoe.

Breakfast Battle

Charlie Parker's also competed in the national Thomas' Hometown Breakfast Battle. Mike Murphy used Thomas' English Muffins to create a breakfast horseshoe. He won the $25,000 prize in October 2015. Mike spent six weeks encouraging online voting. He even made the dish on Fox News Channel's *Fox and Friends* in New York City. He shared the prize money with restaurant staff according to a *State Journal-Register* article. The recipe is in the appendix.

Charlie Parker's winning breakfast horseshoe with a Thomas' English Muffin in 2015. *Charlie Parker's.*

The Biggest 'Shoe

Café Brio created the biggest horseshoe ever during the Taste of Downtown on July 7, 2013. Radio station WDBR (part of Capital Radio Group) sponsored the event, and the money raised went to Children's Miracle Network. The horseshoe was 57 inches long, 44 inches wide, used 150 pounds of ground beef, 10 pounds of Café Brio's signature chipotle cheese sauce, over more than 100 pounds of fries. This was on over 40 pounds of homemade focaccia onion bread. The whole concoction weighed more than 400 pounds—www.recordsetter.com has a video available.

The Illinois State Fair contacted Joe Rhodes of the Red Coach Cattle Company to create the largest horseshoe sandwich in 2005. He enlisted the help of Poe's Catering. The 720 pieces of toast; 180 hamburgers, slices of roast beef, turkey and ham; 180 pounds of French fries; and 35 gallons of

cheese sauce made a 20-foot-long, 4-foot-wide "Clydesdale." Portions were sold after the creation was complete as a fundraiser for 4-H. Brio's was quite a bit bigger in dimensions, but the fair 'shoe had more fries.

World Horseshoe Eating Contest

The www.goldenpalace.net World Horseshoe Eating Championship was a ten-minute competition at the Illinois State Fair on August 12, 2006. "Just as horseshoes mounted on a door signal good luck, Illinois horseshoes—two pieces of toast topped with ham, French fries and cheese sauce—signal good eating. While social eaters throughout the Midwest have revered horseshoes for their nutritional content, this regional treat had yet to be eaten in competition." The winner was Joey Chestnut, who ate six pounds, five ounces.

Challenges/Clydesdales

A Clydesdale is a very large horseshoe that is sometimes just eaten, while other places offer challenges that involve winning prizes or recognition. Some places also use different names for their giant horseshoes. These are listed under "Specialty 'Shoes."

The Monster 'Shoe Challenge at Carlinville (Illinois) Plaza Café: eat five large slices of Texas toast, five half-pound burgers (two and a half pounds total), topped with two pounds of French fries, smothered with two pounds of cheese sauce, in less than 1 hour. Prizes are a free meal and a picture on the Wall of Fame. The cost otherwise is thirty dollars. The food challenge difficulty is considered "moderate" according to www.foodchallenges.com.

There was an almost identical challenge called the Richard's Clydesdale Horseshoe Challenge at Richards Pub and Grill on Main in Peoria, Illinois. This one was half a pound each of hamburger, ham, turkey, chicken strips (total two pounds) with seven pieces of Texas toast, two pounds of fries and two pounds of "our zesty cheese sauce." It had to be eaten in forty-five minutes to get the same prizes—a free meal and a picture on the wall. The cost otherwise was thirty-five dollars. Sadly, Richards is now closed.

Depot Diner in Virginia, Illinois, has a Clydesdale of "triple the meat, 4 slices of Toast + even more French fries and cheese sauce." If eaten (there doesn't appear to be a time limit), a picture will be placed on the "The Depot's Clydesdale Hall of Fame." Cost is $12.99.

The Horseshoe Lounge in Collinsville, Illinois, has the Chili Cheese Horseshoe Challenge. (This is called the "I could eat a horse" on the menu.) It is rated as having "moderate difficulty" at www.foodchallenges.com. This one has four giant three-quarter-pound burger patties on top of four thick slices of Texas toast. This is topped with one and a half pounds of French fries, smothered with eighteen ounces of melted Monterey Jack cheese. Adding twelve ounces of homemade chili brings the total weight to about five and a half to six pounds. There is a thirty-minute time limit to finish. The cost is $27.99 unless the challenge is completed. The prizes are the usual free meal and a wall of fame photo.

The Boar's Nest (Athens, Illinois) Clydesdale Horseshoe Challenge is also rated as "moderate difficulty" on www.foodchallenges.com. Four slices of Texas toast are covered with four servings of one or two choices of breaded or grilled buffalo chicken, pork tenderloin, bacon, chicken strips, hamburger,

Boar's Nest Clydesdale Challenge. *Boar's Nest.*

ham, turkey or chili. This is topped with about two to two and a half pounds of crinkle-cut French fries, smothered in about thirty-two ounces of melted cheese (eight ladles). Total weight is about six pounds. There is a one-hour time limit to finish. The cost is $18.50 for a regular or $21 for a "Specialty" 'shoe, according to the website. The prizes include a free meal, a free T-shirt and a wall of fame photo.

Perdue's Grill in Tremont, Illinois, has a Four Horsemen Challenge, which includes a horseshoe. "Eat a hamburger, hot dog, breaded pork and ham horseshoe in 1 hour or less and receive a t-shirt and a $20 gift card to use on your next visit! Will your name end up on our wall of fame or our wall of shame?! $30.99 (dine-in only and absolutely no sharing)."

According to www.eatfeats.com, Ted's Garage in Clinton, Illinois, is supposed to have a "Big Rig" challenge of a four-and-a-half-pound horseshoe that has to be eaten in thirty minutes. It doesn't appear on their menu.

A Clydesdale Challenge/Barbeque Eating Challenge at Brickhouse Barbeque in Jacksonville, Illinois, also showed up on www.eatfeats.com. It includes: eight ounces of pulled pork, pulled chicken, beef brisket and turkey, two pounds of French fries and cheese sauce on four pieces of Texas toast in thirty minutes. Prizes are one free meal and T-shirt. This is not on the menu.

Specialty 'Shoes

There are several variations of the traditional horseshoe. Some restaurants have larger horseshoes that are not competitive and are not called Clydesdales. The Brickhouse has an "Ultimate," Lake Springfield Tavern and Leann's Parkway Café both offer a "Big Ox." The Westwoods Lodge's "Yetti" has a T-shirt. These are a few examples, described in the restaurant section. Other specialties are described next.

Obama 'Shoes

The *State Journal-Register* asked a few chefs to create "Obama 'shoes" in honor of his inauguration as president in January 2009. Since Obama was from Chicago, he spent time in Springfield when he was a state legislator.

Obama 'Shoe created in 2009 by Chef Michael Higgins. *Maldaner's.*

He must have had a horseshoe at some time. In a speech to the Illinois General Assembly in February 2016, he actually said, "I can't say that I miss horseshoes." Maybe he should have tried one of these.

Michael Higgins from Maldaner's created a Chicago-style hot dog (split and toasted) with "Obama Family Chili" topped with French fries and rarebit cheese sauce with pickle relish and celery seeds. D'Arcy's Pint co-owner Hallie Pierceall created a Hawaiian horseshoe, which reflected Obama's childhood. It included a seasoned hamburger patty, cheesy rice, a fried egg, French fries, cheese sauce and brown gravy topped with paprika and parsley. It was served with grilled pineapple, a tomato rose and hot sauce. (Hawaii has a "Loco Moco," which uses gravy, rice and a fried egg.) The Sangamo Club made a "Healthy Polynesian" with toasted sweet bread, baby greens, radish sprouts, ginger vinaigrette, seared ahi tuna, chili-aioli sauce and fried sweet potatoes.

A YouTube video titled "Barack Obama Horseshoe" by Shannon Kirshner and David Spencer shows the chefs creating their 'shoes with their explanations of why they chose their approaches. We heard Michael Higgins say, "Making a horseshoe healthy is like putting lipstick on a pig."

Ponies

According to an article in "The Limited Edition," the State House Inn began serving "a half horseshoe for lighter appetites," which became the pony 'shoe. This would be healthier because it would have less fat and calories. Many restaurants offer this choice. There is an even smaller Shetland or children's 'shoe at some places.

Breakfast 'Shoes

A few restaurants offer breakfast 'shoes. One of the first was Charlie Parker's Diner. Some of the others include Amber Jack's Alehouse, Route 66 Mother Road Diner, Parkway Café, Café Coco and Cook's Spice Rack and Chili Company. (Charlie Parker's still has its award-winning breakfast 'shoe available.)

Dessert 'Shoes

Only a few places have offered dessert horseshoes over the years. Field of Sweets and Cooper's Alleyside both had dessert 'shoes at the 2017 'Shoes and Brews. Scoop du Jour in Chatham, Illinois, has a photo of its Ice Cream Horseshoe on its website.

Horseshoe Pizza

Although several pizza restaurants have horseshoes, most of them are "traditional" 'shoes. Only a couple of places actually have "horseshoe pizza." The Hawk's Nest Café in Riverton, Illinois, offered a 'shoe pizza until it closed. The Corner Pub and Grill appears to be the only place in Springfield that has them. The Burger Barge in Peoria and East Peoria might also have one.

Dessert horseshoe made with ice cream. *Scoop du Jour, Chatham, Illinois.*

Pizza horseshoe from the Corner Pub & Grill. *Carolyn Harmon.*

Horseshoe Burrito

A few Mexican restaurants have created horseshoe variations. The Field House Pizza and Pub had a deep-fried "Shoe Burrito" that was discussed in the *Wall Street Journal*.

Horseshoe Spoon

Secret Recipes catering offers a "Horseshoe Spoon" appetizer created by Chef Chip Kennedy. Secret Recipes Catering works in conjunction with the Abraham Lincoln Presidential Library and Museum. It served the Horseshoe Spoon at the Springfield Chamber of Commerce's First 'Shoes & Brews in 2017. The Horseshoe Spoon is described in the Tasting section, and the recipe is provided in the appendix.

Horseshoe Spoon appetizer. *Secret Recipes Catering.*

Magic Mountain

Several restaurants in Iowa use steamed "loose meat" hamburger to create something similar to a horseshoe. The most famous is the "Magic Mountain" at Ross' Restaurant in Bettendorf, Iowa. This is described in detail in the restaurant section in chapter 5.

Horseshoe Tasting

A few horseshoe tasting events without competition have also been held in Springfield. The Springfield Chamber of Commerce hosted the First Annual 'Shoes & Brews at Southwind Park in 2017. Several horseshoes were available to sample along with local beers. Cooper's AlleySide had three choices: a chorizo with "Coop's Cheese Sauce," a hamburger 'shoe and a dessert horseshoe with sweet and spicy tortilla strips, whipped cream, caramel and chocolate shavings. Qdoba Mexican Grill introduced its "Q 'Shoe." This bowl comes with tortilla shell pieces, rice, beans, meat and Qdoba's "awesome" queso cheese sauce. Route 66 Hotel and Conference Center made Philly steak horseshoes with onions, green peppers and the expected fries and cheese sauce. La Fiesta Grande's 'shoe was a tortilla covered in chicken or steak strips with fries and La Fiesta Grande's queso cheese sauce. Secret Recipes brought the Horseshoe Spoon. The 'shoe of Kobe beef, classic cheese sauce and Idaho potato fries was presented in a large spoon. One more dessert offering was provided by Field of Sweets. It featured pound cake covered with vanilla ice cream, house-made chocolate sauce and chocolate chip cookies cut like French fries, smothered with whipped cream.

Taste of Downtown by Downtown Springfield

Taste of Downtown began in 1999 in conjunction with the American Music Festival. Restaurants did not include horseshoes the first couple of years. They started appearing by 2003. Caitie Girl's offered its innovative BBQ pork horseshoe with pepper jack cheese sauce and tricolor fries (sweet, russet and Yukon gold potatoes) served on jalapeno cornbread from about 2007 to 2011. Taste of Downtown did a special tribute horseshoe to Caitlin Barker after her death. In 2013, there was a pot roast horseshoe. By 2015, Downtown Springfield started having a food theme. The first was bacon, which left horseshoes out. In 2017, the name changed to the Amaranth Apple Festival. Restaurants that participated included B&W Good Eats & Treats Food Truck, which had a walking pony 'shoe.

The Horseshoe Buffet

A few places have produced a horseshoe buffet. The Dublin Pub has a trademarked "Ponyshoe Bar" as part of its catering menu. The Brickhouse Grill and Pub had a horseshoe buffet for a reception. Turasky's Catering offers a horseshoe buffet, while Secret Recipes calls it a horseshoe bar. Kicks also had a horseshoe bar for the three years it was open. The University of Illinois at Springfield provided a horseshoe buffet at a Sage Society Lunch and Learn about horseshoes in February 2017. A Hy-Vee in Macomb appeared to have a horseshoe bar for one day according to a Facebook post.

Equine Fundraiser

The horseshoe sandwich makes a great fundraiser for horse-related charities. Horseshoes for Hope in Paris, Tennessee, did horseshoe fundraisers in 2014, 2015 and 2016 in conjunction with the R.E.A.L. Hope Youth Center. (The Director of the R.E.A.L. Hope Youth Center is originally from Springfield, Illinois.)

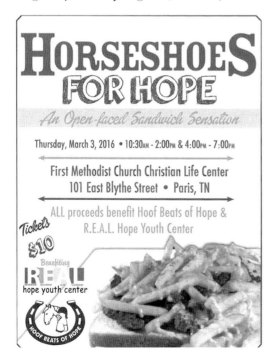

Horseshoes for Hope poster in Paris, Tennessee. *R.E.A.L. Hope Youth Center.*

A Healthy Challenge

Although the horseshoe has been called "a heart attack on a plate," there have been attempts to make it healthier. The *Wall Street Journal* suggested the usual horseshoe has 1,900 calories. In 2003, the *State Journal Register* had an article about a challenge sponsored by St. John's Hospital and the Prairie Heart Institute to create a healthier horseshoe. The Midwest Affiliate of the American Heart Association wanted Lincoln Land Community College culinary arts students to create a horseshoe with at least 25 percent less fat. (Most horseshoes have about sixty-five grams of fat.) The winner made a cheese sauce with Neufchâtel cream cheese and low-fat evaporated milk. She also used ground turkey breast rather than ground dark turkey to make a burger. She baked the fries and dusted them with paprika.

The Prairie 'Shoe was created by Sara Lopinsky, a dietician with the Prairie Heart Institute, in the same year (2003) for Norb Andy's. An article in the *State Journal-Register* said she used low-fat cheese, baked French fries and alternative meat like a turkey or garden burger.

When Chef August Mrozowksi wanted to create a healthy horseshoe for himself, he tried a variety of vegan cheese sauce recipes. His favorite is used for the horseshoe available at Augie's Front Burner's "Meatless Mondays."

Many restaurants offer a veggie or black bean burger horse or pony 'shoe. Vegetables like portobello mushrooms can also be used in place of meat. Restaurants that don't have a veggie 'shoe listed on the menu can usually create one. Using vegetables or veggie burgers does make a horseshoe healthier.

Horseshoes can also be made gluten free pretty easily. Using gluten-free flour in the cheese sauce and an alternative for the bread is all that is usually needed.

Recipes with healthier alternatives, including a recipe for vegan horseshoe, are included in the appendix.

MEMORY LANE

*S*pringfield restaurants that served horseshoes but are now closed are listed first. Then, a few restaurants from surrounding communities that also belong in horseshoe history are described. Many of the Springfield restaurants have been discussed on the "Memories of Springfield" Facebook page.

Abe's South Side Café

3751 South Sixth Street

Abe's opened in the Travellodge in 2011. The hotel was previously the Econo Lodge, Springfield Inn and originally opened as the Ramada Inn about 1965. The Ramada Inn showed horseshoes on the menu in 1976. Abe's had the Abe's 'Shoe or a little pony with homemade white sauce. By 2014, the hotel was called the Lodge and the property was demolished. Reflections Lounge also showed horseshoes on the menu in 1998, and the Lighthouse was in the hotel from 2008 to 2011 and then moved to Rochester in 2012. It is still open and serves horseshoes.

Amber Jack Alehouse

3150 Chatham Road

Amber Jack Alehouse was opened in 2004 by the McHenrys, who previously ran the Barrel Head. Amber Jack's had a breakfast 'shoe of bacon, sausage patty or links or ham with tater tots or hash browns, eggs and cheese sauce, sausage gravy or both. The horseshoes included the regular choices as well as turkey/ham combination, stir fry, pork chops or something called "chef's pride." Amber Jack won an award for Best Dessert 'Shoe at the 2009 World Horseshoe Cook-Off.

Aunt Jean's Taste of Soul

2300 East Cook Street

Gloria Jenkins first was a chef at On Broadway in 1994 when she won the Springfield Parks Foundation Horseshoe Showcase for cheese sauce. She opened her restaurant two years later in 1996 and won the Judge's Choice award at the Springfield Parks Foundation Horseshoe Showcase. She won again in 1997 with a spicy pork horseshoe. Gloria said her cheese sauce had secret spices and American cheese but no milk in a *State Journal-Register* interview. Although there was just a sign on the door when the restaurant closed in 1999, the theory was the location was a problem.

Baur's Opera House

620 South First Street

George Baur opened Baur's in 1976 after working at the St. Nicholas Hotel as a chef. Baur's was located near the capitol complex, so it was a popular spot with legislators. Baur participated in the Springfield Park District Horseshoe Showcase/Taste of 'Shoes from 1993 to 1997. The restaurant won Best of 'Shoe in 1993 and 1995 and took home the Golden 'Shoe for the people's choice in 1994. In 1997, it won for the cheese sauce and overall presentation. Baur's closed in 1999.

Beef 'n Brew Restaurant

1701 North Walnut Street

The restaurant was connected to the Best Western Sky Harbor Inn and was open from about 1984 to 1986. Denny Joslin, the owner, mentioned in an article about the restaurant that he got his horseshoe recipe from Ray Kyle. Horseshoes were obviously on the menu.

B&G Café

2606 South Sixth Street, 1107 East Ash Street,
2372 North Grand Avenue East

B&G was purchased by the Kapshandys around 1980. They moved the café from Sixth Street to Ash Street in 1989 and by 1997 had another location on North Grand Avenue. When they sold in 2004, the new owner said he would keep the signature dishes, including horseshoes. Both locations were closed by 2009.

Biloxi's

White Oaks Mall, 2501 Wabash Avenue

Open from about 1994 to 1995, Biloxi's had a "Preferred 'Shoe" with a "little touch of Biloxi Red" in the cheese sauce at the Springfield Parks Foundation Horseshoe Showcase.

(The) Boulevard Grill

2413 South MacArthur Boulevard

The Boulevard was a "new" entry in the Horseshoe Quest 2011. It was only open for a couple of years and had multiple owners.

Café Brio

524 East Monroe Street

Curtis Hudson and Matt Burke opened Café Brio in 1996. They had at least "five takes on the horseshoe" according to a newspaper article. These included hamburger, grilled chicken, bacon, jalapeno bacon, turkey, ham, pulled pork, fresh veggies, steak or corned beef and chipotle cheese sauce. Café Brio made a record-breaking horseshoe in 2013 (see chapter 2). Brio's original owner, Curtis Hudson, sold it in 2009. With a succession of four different owners, it finally closed in 2015.

Café Coco

3705 North Dirksen Parkway

Although known for pies, Café Coco also had horse and pony 'shoes, for breakfast and lunch, with the usual choices. The café had a fish 'shoe on Fridays. A person who worked there said she was picky about cheese sauce, and Café Coco's tenderloin 'shoe and cheese sauce was "the best" anywhere.

Capitol City Brewing Company Bar & Grill

Vinegar Hill Mall, 107 West Cook Street

Capitol City was open in 1994, when it participated in the Springfield Parks Foundation Horseshoe Showcase with hamburger, ham and turkey 'shoes that had "special cheese sauce with beer." In 1995, Capitol City won for best French fries. It brought a traditional ham, hamburger or turkey 'shoe with cheese sauce made from the brewery's Australian ale.

Carlos O'Kelly's

2500 Sunrise Drive

Carlos O'Kelly's was open from 2004 until about 2010, when it was mentioned in the *Wall Street Journal* article as having horseshoes. Although the restaurant is no longer in Springfield, there are locations around the country. The current menu does not have horseshoes.

Caitie Girl's

400 East Jefferson Street

Aubrey Caitlin Barker was a homegrown chef who studied at Lincoln Land Community College before opening her eclectic Caitie Girl's in 2007. She revamped the 1950s Glade Room of the former St. Nicholas Hotel with vibrant colors and art. She participated in Local Flavors, the Taste of Downtown and other community events. Her usual horseshoe was a BBQ pork horseshoe with pepper jack cheese sauce and tri-color fries (sweet, russet and Yukon gold potatoes) served on jalapeno cheddar cornbread. (It

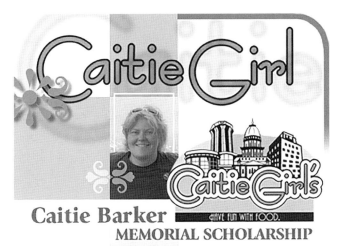

Caitie Barker
MEMORIAL SCHOLARSHIP

A scholarship, in memory of Caitie Barker, owner of Caitie Girl's Restaurant, has been established at Lincoln Land Community College.

Our thanks to the **Fat Ass 5K & Street Party for Charity** for donating $1,500 to create this opportunity for future "Caities." Help us make this donation go even further and reach our goal of an additional $1000!

As Caitie would say …
"It's all good."
Help us "make it good" for future LLCC students.
Donate now at
www.llccfoundation.org
and click on *Make a Gift to Caitie Girl.*

Caitie was known for her hard work and determination to succeed. Caitie often attributed her success to the training she received in the LLCC Culinary Program. Also very important to her was assistance from the Illinois Small Business Development Center at LLCC.

Caitie Girl's restaurant was the realization of her vision. On a shoestring budget and with the help of friends and family, she transformed the dining and kitchen area of the old St. Nicholas Hotel into a bright, funky and welcoming space.

A flyer about the Caitie Barker scholarship at Lincoln Land Community College. *LLCC Foundation.*

was awesome!) Caitie Girl's was one of the stops on Horseshoe Quest 2011. Sadly, Caitie died in car accident on the way to a catering job in 2011. One person wrote, "There will be a horseshoe-shaped hole in Springfield's heart where you once were." At Taste of Downtown the following summer (2012), there was a Caitie Girl's Horseshoe tribute. Lincoln Land Community College Foundation also established a scholarship in her name. Caitie Girl's was a runner-up for the Abe Awards, voted on by local high school students and a runner-up for Best Unique Horseshoe (*Illinois Times*) in 2009.

(The) Chardel Restaurant
2615 East Cook Street

The Chardel was mentioned on the "Memories of Springfield" Facebook page. It probably opened about 1972. It was owned by William (Bill) Delmar and Charlie Kresse, who also owned John's Supper Club/ Yesterdays at about the same time. They sold the Chardel to Guy Haseltine in 1975. Horseshoes continued to be on the menu, and some people thought they were very good. Dennis Price was a chef there before opening D&J Café. The Chardel became the Rusty Pelican about 1980. Because of a dispute about the name, it was changed to Tiger Tail in 1984. The building was sold to Dennis Joslin in 1986.

Coney Island
"Coney Island Building" at 114 North Sixth Street

Hercules Gekas opened Coney Island in 1919. Coney Island Red Hots was located in the Coney Island Building in 1931. The "Coney Island Building" was at 114 North Sixth Street. It became the Coney Island Restaurant in 1935. Coney Island was forced to relocate to 210 South Fifth Street when the building was torn down for the Abraham Lincoln Presidential Museum in 2000. Coney Island moved to 219 South Fifth Street before closing in 2012. It reopened briefly as Emilio's Coney Island at 1101 South Ninth Street. The original building was on Historic Route 66.

Although it is unclear when it began serving horseshoes, the restaurant won the Best 'Shoe at the 2002 Springfield Parks Foundation Horseshoe

Coney Island. *Sangamon Valley Collection*.

Showcase. A person wrote about his experience with a Coney Island pony 'shoe on July 5, 2002, as part of a Route 66 road trip. His description showed up on several sites, including www.chowhound.com (2002) and at www.LTHforum.com (2005). The counter person said the restaurant had an "award winning white sauce." and the writer seemed to agree. He described the cheese sauce as "a thick, rich sauce, really a béchamel, not velveeta-y, not like ballpark nacho sauce." (Tommy Cerri, a manager at Coney Island, said that he began using a white cheese sauce about 1991 when he was at Chatter's in Chatham, Illinois, in a *State Journal-Register* article in 2002. He said he made the sauce with a combination of white cheese, 2 percent milk, Tabasco and Worcestershire sauce. "I think it's a lighter, fluffier sauce.") The writer found the sandwich "did Springfield proud."

Corky's Ribs & BBQ

3458 Freedom Drive

The Springfield location had a "Corky's 'Shoe," which came in a horse or pony size. The 'shoe had a choice of hickory-smoked meats and a cheese sauce made from American and Swiss cheese. A column in the *State Journal-Register* in 2002 indicated Corky's wanted to expand horseshoes to other locations, but horseshoes are not currently on the national menu. The Springfield location closed in 2008, despite having won the "Best Pitch" at the 2004 Springfield Parks Foundation Horseshoe Showcase.

Dippers

Sangamon Center North, 1861 East Sangamon Avenue

Open from about 1998 to 2002, Dippers participated in the 2000 Springfield Parks Foundation Horseshoe Showcase. Results were not available for that year. The restaurant was decorated with historical memorabilia, according to a *State Journal-Register* article.

Douger's

6901 Preston Drive/1701 J David Jones Parkway

Douger's, named after owner Doug Hamrick, was at Piper Glen in 1998 when it won an award for overall presentation at the Springfield Parks Foundation Horseshoe Showcase. It closed in 1999 and reopened briefly in 2003 at the Howard Johnson's near the airport.

(The) Fairview Restaurant/Restaurante

2141 North Sixteenth Street

The Fairview Tavern opened in 1945. After a fire, it was rebuilt. In 2010, it reopened as the Fairview Restaurante after being closed two years. When it reopened in 2010, the menu said it had horseshoes. The Fairview was also mentioned in the Gonko article in 1979. A couple of reviews on Facebook described the horseshoes as "great" and "awesome." It closed for good in 2017.

Field House Pizza & Pub

3211 Sangamon Avenue

A *Wall Street Journal* article featured the 2,700-calorie "Shoe Burrito" in 2010. Joe Barrett describes the 'shoe this way: "Field House adds an extra layer of grease by stuffing the meat and fries into a tortilla, which stand in for the bread, and dunking the mass in a deep-fryer before ladling on the cheese sauce." Even with the publicity, Field House closed in 2010 after being open about ten years.

Field House Pizza & Pub. *Sangamon County.*

(The) Fleetwood

855 North Dirksen Parkway

The Fleetwood was open from 1957 to 1993. According to several people on Facebook pages, it had horseshoes. Dennis Price got his start as a dishwasher at the Fleetwood before going to the Chardel and eventually opening D&J Café. The Fleetwood was part of Historic Route 66 history.

Green Turtle

418 East Jefferson Street

The Green Turtle was open from about 1983 to 1989 in the Capitol Plaza Hotel, which by then was a historic building. The Capitol Plaza was previously the Hotel Governor, the Empire Hotel and the Empire Theater and Saloon. The horseshoe was described as having a "pleasant, tangy sauce" in a review by Charlyn Fargo in 1984.

Gumbo YaYa's

Springfield Hilton Hotel, 700 East Adams Street

Open from about 1994 to 2003, Gumbo YaYa's participated in the Springfield Parks Foundation Horseshoe Showcase in 1995 and 1996. In 1995, it won the Presentation and Trailblazing awards for a shaved rib eye on French bread with wedges of baby new potatoes.

Harness House

1305 Wabash Avenue

George Harness opened a place on Spaulding Road where he could play his trumpet in 1965. He moved to Wabash Avenue in 1966. He and his wife, Mary, served horseshoes according to a "spotlight" advertisement in the *State Journal-Register*'s "Your Guide to Good Eating" in May 1971. Harness

House was open until 1974. George continued to play trumpet and promote musical groups.

Holiday Inn East

3100 South Dirksen Parkway

John Danko was an executive chef at the Holiday Inn after working with Steve Tomko at the Leland Hotel and John's Lounge. He brought horseshoes to the Holiday Inn restaurant, which was open from 1965 until the hotel was torn down in 2000.

Horseshoe Pub

2441 South MacArthur Boulevard

Open from 1984 to 1986, Gabe Chiaro, the owner said his horseshoe cheese sauce was a combination of the Red Coach and Norb Andy's recipes in the Jay Fitzgerald article in 1986.

Johnny's at Kingpin Lanes

3115 Sangamon Avenue

Johnny's won "Best Pitch" for presentation at the Springfield Park District Foundation Horseshoe Showcase in 2005. It was still open in 2012 but was closed by 2016.

John's Lounge

130 West Mason Street, corner of Klein & Mason

John Semanik needs to get some credit for the continuation and popularity of horseshoes. He ran John's Lounge from 1960 to 1970 in the previous Steve & Lee's. (Steve was Steve Tomko, who stayed on until he and Wayne left to open Wayne's Red Coach.) The story of the cheese sauce modification is told in chapter 1. Another cook, Mary Pate, said she used Worcestershire

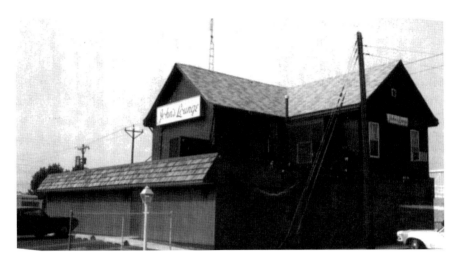

John's Lounge. *Sangamon County*.

sauce in 1972. In a phone interview, Verney Blackburn described John as a nice guy who created a family atmosphere. The bowling team was also successful.

John's Supper Club

130 West Mason Street

New owners Bill and Charlie Kresse refurbished the John's Lounge building in about 1973. They continued to offer horseshoes (eight kinds) from 1970 until about 1980, when the building became Yesterdays, which was open until about 1984.

Kicks Family Entertainment Center

2744 South Sixth Street

Kicks opened in 2006. Along with an assortment of games, it had a buffet that included a horseshoe bar. It closed briefly in 2009, reopened without food and then closed again.

Kitty's Courthouse/Miss Kitty's

131 East Jefferson Street/117 North Second Street

Kitty's Courthouse was open from 1996 to 2002. Kitty and Roger Ramirez were the owners. Before that, Kitty managed Miss Kitty's from 1990 to 1996. Both places had horseshoes. Kitty's Courthouse even had a breakfast 'shoe. Miss Kitty's won the No Small Fry award at the Springfield Parks Foundation Horseshoe Showcase of 1994.

Linda's Five Day Café

2625 South Sixth Street/1629 North Ninth (Peoria Road)

Linda's opened on South Sixth Street in 1996 and moved to North Ninth in 1998. In 2000, the café was sold and became JB's Café. It had a horseshoe and added a breakfast 'shoe in 1999. Linda Drone, the owner and chef, had previously worked at the Red Coach Inn, Sunset Grill and Lake Springfield Tavern, according to an article in the *State Journal-Register*.

(The) Livery

518 East Adams Street

The Livery was one of several restaurants in this location that had horseshoes. A poster advertised the horseshoes. The restaurant was only open for a few months in 2007.

The Livery poster. *Wendy Davis Dearing.*

Lu's Home Tavern

1031 South Eleventh Street

Lu's was open from about 1959 until 1994. Horseshoes were mentioned in a 1994 article in the *State Journal-Register* and on the "Memories of Springfield" Facebook page.

Main Gate Lounge

Eleventh and Sangamon Avenue

Open from 1981 to 1982, Main Gate Lounge had horseshoes.

Mangia Bene at Two Olives Cantina

518 East Adams Street

Open from 2009 to 2011, Mangia Bene brought horseshoes from Two Olives and a Pepper in Vinegar Hill Mall.

Mansion View Restaurant and Lounge

517/529 South Fourth Street

In the Bob Gonko article in 1979, Jesse Williams, the chef, said he made five gallons of cheese sauce a day for his horseshoes. His cheese sauce was made from sharp cheddar, Worcestershire, Tabasco, prepared mustard, dry milk and "dry beer." Mansion View was open from about 1964 to 1979.

McCormick's Restaurant

2930 Plaza Drive in the Gables

McCormick's opened in downtown Springfield in 1994. It moved west in 1997 and added horseshoes to the menu in 1999. The menu read: "Our customers tell us our Homemade white cheese sauce is 'Hands Down, the best cheese sauce around.'" McCormick's offered fifteen meat choices, including a pulled chicken, Reuben or beef brisket 'shoe. And sprinkled on the top: "our house blended Hog Heaven Seasoning."

(The) Midway Pub

203 West Cook Street

The Midway was open from 1972 to 1983. Articles about the owners Ray and Linda Benton and Lee Tintori do not mention horseshoes, but the pub was listed as having horseshoes in the Gonko column of 1979.

(The) Mill

906 North Fifteenth Street

The Mill opened in 1933 and was sometimes called Harry Cusick's Mill Tavern until he left the following year. It was called the Mill because it was located near the Pillsbury Mills. When Cusick left to run the Sazarac, the Cohen brothers took over. Some of the chefs from the Leland Hotel worked at the Mill over the years, including Tony Wables and Joe Schweska. By the

The Mill. *Sangamon Valley Collection.*

late 1940s, it had horseshoes on the menu but called it a "Welsh Rarebit Platter." The Mill reopened after a fire in 1940. It burned down in 1972 and did not reopen. The Mill was mentioned in a few *State Journal-Register* articles, and the *Sangamon Link* by the Sangamon County Historical Society had a big article about this historic restaurant.

New England Lobster House

1710 South MacArthur Boulevard

Although open from 1980 to 2004, horseshoes may not have been on the menu until about 2001. The main focus was originally lobster and seafood (although horseshoes can be made from fish).

(The) Norb Andy's Tabarin

518 East Capitol Avenue

Norbert Anderson ran Norb Andy's from 1938 to 1979. Steve Tomko supposedly worked there at some point. Since Norb's was right across the street from the Leland Hotel, it is likely it started serving horseshoes earlier than many other places. Mary Bailie said that she added wine to her cheese sauce in a 1986 interview for a *State Journal-Regsiter* article. She wouldn't divulge the rest of the recipe. Joan Draughen said she used A.1. Steak Sauce, Tabasco and wine in 1972. Norb Andy's offered the Prairie 'Shoe in 2003 as a healthy alternative to a traditional horseshoe. It was developed by Sara Lopinski, a dietician with Prairie Heart Institute and the American Heart Association. Burt Wolf visited in 2014 for a *Local Flavors* segment. He created a horseshoe at the Inn at 835 but used Norb Andy's French fries. Josh Bales, the chef at Norb Andy's, presented some of the most popular 'shoes, including the club (ham, turkey, bacon and tomato), the chili cheeseburger with green onions and a seafood pony (shrimp, crab, tomato and scallions). When Stevie Zvereva visited Springfield in 2014 for a www.peoriamagazines.com article, she interviewed Collin Smith, the chef at that time. He said he used both white and yellow cheddar cheese along with "beer, cayenne pepper, salt and pepper."

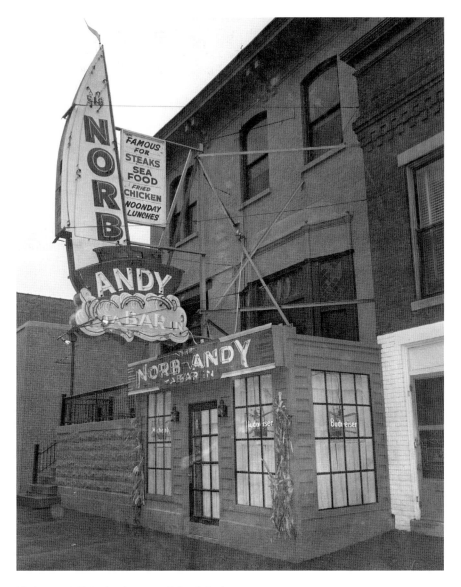

Norb Andy's Tabarin. *Sangamon Valley Collection.*

Norb Andy's won the Golden 'Shoe People's Choice in 2002 and best cheese sauce in 1998 at the Springfield Parks Foundation Horseshoe Showcase. In 2004, Norb's horseshoe was so popular that they ran out before the judges got there. It also was part of the Horseshoe Quest in 2011. After a succession of owners and openings, it finally closed in 2015.

Omar's Latin Fusion

6901 Preston Drive

Omar's had a Mexican horseshoe made from a grilled tostada, grilled chicken pieces, battered fries and queso cheese sauce. It was open from 2015 to 2018.

On Broadway

210 Broadway Street

On Broadway opened in 1985. Owners Steve Morrison and Ed Martin won the 1994 Big Cheese award at the Springfield Parks Foundation Horseshoe Showcase with the help of chef Gloria Jenkins. It stayed open until 2002.

Red Lion Tavern, Leland Hotel

Northwest Corner of Sixth Street and Capitol Avenue

The Red Lion opened in 1956 in the Leland Hotel. The first Leland Hotel was built in 1867. After a fire in 1908, it was rebuilt and reopened in 1911. (More about the Leland Hotel can be found in chapter 1.) The Red Lion was famous for horseshoes. The Leland manager at the time was Jim Bolinger. (When some people from Springfield visited Bolinger's Supper Club near Pipestem, West Virginia, in 1993, they found a "horseshoe platter" on the menu and asked about it. Bolinger claimed he "introduced" the horseshoe, when Toby McDaniel wrote a column about the visit in 1993. It is unclear if the horseshoe was served at the Leland restaurants after Joe Schweska moved to Decatur, so it is possible the 'shoe was reintroduced. Trice D. Yemm wrote a letter to the editor in response to Bolinger's claim stating that McDaniel was "misinformed.") When the Red Lion opened, the manager was Henry J. Salomon, and the chef was John Rupnik, according to an ad in the newspaper. (An ad for the Leland Hotel from 1952 showed John Rupnik as the chef.) The Sangamon County Historical Society's *Sangamon Link* tells about the Leland Hotel's six-hundred-acre farm, which supplied much of the food for the hotel. The area is now Leland Grove and Oak Knolls.

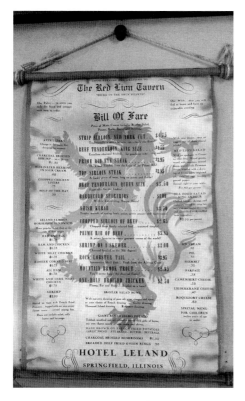

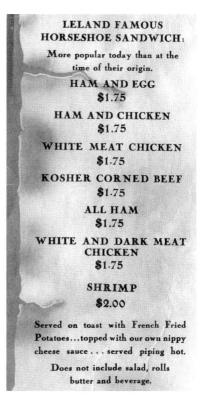

LELAND FAMOUS HORSESHOE SANDWICH:

More popular today than at the time of their origin.

HAM AND EGG
$1.75

HAM AND CHICKEN
$1.75

WHITE MEAT CHICKEN
$1.75

KOSHER CORNED BEEF
$1.75

ALL HAM
$1.75

WHITE AND DARK MEAT CHICKEN
$1.75

SHRIMP
$2.00

Served on toast with French Fried Potatoes...topped with our own nippy cheese sauce ... served piping hot.

Does not include salad, rolls butter and beverage.

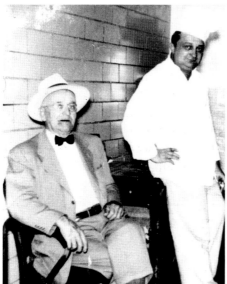

Above, left: Red Lion menu. *Tony Leone*.

Above, right: Red Lion menu, horseshoe section. *Sangamon Valley Collection*.

Left: John Rupnik Jr., Leland Hotel chef (*right*), and Jim Bolinger, manager. *Joe Rupnik*.

The Old English–themed restaurant finally closed in 1970, about the same time as the hotel, which had become the Leland Motor Hotel. Bolinger was the manager from 1948 until 1969. People were supposedly eating horseshoes when the power was turned off to the restaurant and John Danko was the chef. There was some hope of the hotel reopening in 1971, but the building was eventually sold and was used by Sangamon State University. It now houses the Illinois Commerce Commission.

The horseshoe recipe from the Red Lion also can be found in *Springfield Eats: A Book of Capital Cuisine*, published by SPARC in 1994.

Riccardo's

Ninth and Peoria Road

Riccardo's was mentioned in a post about horseshoes on the "Memories of Springfield" Facebook page. It was open from about 1971 to 1979.

Same Old Shillelagh

951 South Durkin Drive in Clocktower Village

The Same Old Shillelagh opened about 1975 with a "Brog A' Capaill" on the menu. This is otherwise known as a horseshoe. The choices were turkey, ham or hamburger with Same Old Shillelagh special sauce. It closed about 1989 when Lime Street Café opened in the same space. Several people said the Shillelagh 'shoe was the "best" on various websites and Facebook pages.

Sandwich Station

1121 South Grand Avenue East

Sandwich Station was open for only about a year. It participated in the 1998 Springfield Parks Foundation Horseshoe Showcase.

(The) Sazarac

229 South Sixth Street

The Sazarac was open at this location from about 1934 to 1980 and reopened in a different location in 2010 for a short time. Ads sometimes said "Harry Cusick's Sazarac," since he was the manager. Ads from the 1930s said it had "all types of sandwiches." The Sazarac was listed as having horseshoes in the Gonko article of 1979, and at least one person said its 'shoes were "the best" on the "Memories of Springfield" Facebook page.

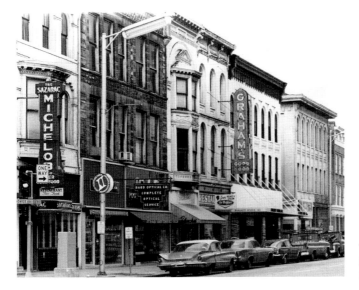

The Sazarac.
Sangamon Valley Collection.

Steve & Don's, Steve & Lee's

130 West Mason Street

Steve was Steve Tomko, who is mentioned with John's Lounge earlier. Steve made horseshoes from at least 1946 to 1962 at this location, until John Semanik purchased the building. (A photo of the softball team is in chapter 1.)

Sunset Grill

1431 South Grand Avenue East (Fifteenth and South Grand)

Sunset Grill was open from about 1991 to 1994 with a sausage pony 'shoe on the menu.

Suzie Q's

716 East Enos Avenue

Suzie Weiss ran Susie Q's from 1983 to 2006. It was a fixture in the Enos Park neighborhood. Susie Q's served the typical horseshoe. One person's review on Yelp said he or she ordered buffalo but got chicken. John in Montana said he had friends who "swear by the 'shoe at Suzie Q's" in 2002 on www.chowhound.com. (John was from Springfield.) Although a new owner reopened Suzie Q's in 2012, it had closed again by 2016. Suzie came out of retirement in 2018 to serve horseshoes at the Mess Hall Restaurant in the American Legion Post 32 on Sangamon Avenue.

Suzie Q's. *Sangamon County.*

Top of the Arch

500 East Ash Street in Iles Park Place

Top of the Arch was open from 1967 to 1986. The Christofilakos family operated Top of the Arch as well as other Springfield restaurants. Top of the Arch was listed as having horseshoes in the Gonko article of 1979.

Towne Lounge

First and Reynolds Street

In a *State Journal Register* article when Towne Lounge opened in 2005, Marje Smith said, "We think we have one of the best horseshoes." It is unclear how long the restaurant was open.

Two Olives and a Pepper

Vinegar Hill Mall, 107 West Cook Street

Open from about 2002 to 2006, Two Olives and a Pepper had horseshoes on the menu.

Vic's Pizza

2025 Peoria Road

Vic's Pizza opened in 1948. By 1998, Joe Rupnik was the third owner. It definitely had horseshoes on the menu by then and won the Best Pitch at the Springfield Parks Foundation Horseshoe Showcase in 2002 for overall presentation. Vic's had a westside location for a couple of years, but Joe was busy with other ventures, so some former employees took over Vic's. It closed soon after in 2014.

Vic's Pizza. *Sangamon County Historical Society.*

Wayne's Red Coach Inn, Red Coach Cattle Company

301 North Grand Avenue West

Wayne Coumbes left John's Lounge to open his Red Coach Inn with his wife, Bertie, in 1971. He brought Steve Tomko and Steve's sister Charlotte with

him from John's Lounge. Tomko stayed until he retired in 1973. Wayne's Red Coach Inn had the distinction of keeping the horseshoe alive according to several articles. It closed in 2002 after thirty-two years. Some former employees reopened briefly as the Red Coach Cattle Company in 2005, but it closed again a year later.

Wayne's Red Coach Inn. *Sangamon County.*

Yesterdays

130 West Mason Street, 625 East St. Joseph Street

From about 1980 to 1984, the former John's Supper Club was called Yesterdays. The Filling Station in the Route 66 Hotel became Yesterdays in 2009, and the name was changed in about 2012. A Yesterdays competed in the Springfield Parks Foundation Horseshoe Showcase in 1996.

Z Bistro

220 South Sixth Street

Z Bistro opened as a "fondue" restaurant in 2000. It made sense to have horseshoes. The menu read, "Horseshoes: a Springfield Original." Choices included hamburger, buffalo chicken, chilli (with onions) or veggie with fries and cheese (fondue) sauce. (Note the chilli has two Ls, which is the Springfield spelling.) It also offered a gyro horseshoe on a pita, with gyro meat, onions, tomato and gyro sauce or a hot dog horseshoe with tater tots, hot dog slices, onions and bacon. It closed in 2017.

CHATHAM, ILLINOIS

Chatters Restaurant and Bar

214 West Chestnut Street

Chatters was open from 1992 to 2003. It served a horseshoe with "revered white cheese sauce." It received the 1995 People's Choice award at the Springfield Parks Foundation Horseshoe Showcase.

DAWSON, ILLINOIS

Country Club Saloon

10230 Old Route 36

The Country Club Saloon was open from about 2003 to 2006. It participated in the Springfield Parks Foundation Horseshoe Showcase in 2004.

EDINBURG, ILLINOIS

Uncle John's Family Restaurant

113 East Washington Street

Uncle John's was run by John Rupnik, one of John Rupnik Jr.'s sons. It was co-owned with his brother, Joe Rupnik. They had horse and pony 'shoes on the menu and were open from about 2006 to 2012.

ILLIOPOLIS, ILLINOIS

Roese Bowl

Route 36

This was a bowling alley with a restaurant that was open from about 1977 to 1986. According to the owner's daughter and some posts on "Memories of Springfield," it had horseshoes.

JACKSONVILLE, ILLINOIS

BJ's Restaurant

1904 West Morton Avenue

Open from about 2011 to 2015, BJ's had breakfast and regular horseshoes.

LINCOLN, ILLINOIS

Hallie's on the Square

111 South Kickapoo Street

Hallie's Lunch Box opened in 2001 and at some point changed its name to Hallie's on the Square. It was a stop on the Horseshoe Quest in 2011. Reviews of the schnitzel horseshoe were generally positive, with one person saying the schnitzel was just as good as any he had in Europe. It also offered the usual choices of meats. Hallie's closed around 2015.

The Tropics

107 Hickox Road

The Tropics opened in 1950 on Historic Route 66. It was sold in 1957. It closed and reopened several times, including after fires in 1965 and 1975. It finally closed in 2003. The McDonald's that opened on the spot where the Tropics was located has kept the historic sign, which was restored thanks to the Tropics Legacy Campaign Committee. Various people reported having fond memories of the Tropics' horseshoe.

The Tropics, Lincoln, Illinois. *Logan County Tourism Bureau.*

PETERSBURG, ILLINOIS

George Warburtons Food and Drink

South Shore Drive

Horseshoes were on the menu when George Warburtons opened in 1989 near New Salem State Park. It closed in 1998 and reopened with new owners but the same name in 2000. It continued to offer 'shoes until closing about 2008. Some people on the horseshoe pages have great memories of the restaurant's horseshoes.

RIVERTON, ILLINOIS

Hawk's Nest Café

1300 North Seventh Street

The Hawk's Nest was open from about 2012 to 2015 and had horseshoe pizza.

SHERMAN, ILLINOIS

Ray's Route 66 Family Diner

110 Villa Parkway

Located on historic Route 66, Ray's had the usual horse and "mustang" pony choices. It was open for more than ten years and closed in 2018.

NILES, ILLINOIS (CHICAGO AREA)

Capone's Hideout

6873 North Milwaukee Avenue

Capone's was open from about 2010 to 2015. It had four types of one-size horseshoes. The "American 'Shoe Sandwich" had a "Capone burger." The "Original" used grilled ham. There also was Polish sausage or Cajun chicken breast. All were served with "grilled onions, peppers, tomato, homemade fries and a secret beer cheese sauce."

PEORIA, ILLINOIS

Richards Pub and Grill on Main

311 Main Street

The website told the interesting history of the building and pub. Under "Build Your Own" there were horseshoes, which included the usual choices plus corned beef and steak. It also had a "Clydesdale Challenge."

ST. LOUIS, MISSOURI

Horseshoe House

6100 Delmar Boulevard

The Horseshoe House was only open a couple of years but had some interesting connections. The restaurant was co-owned by the Springfield, Illinois Maid-Rite manager's daughter. It competed with Moore's Restaurant in Belleville for the best horseshoe in April 2011. It had a traditional 'shoe of two hamburger patties on Texas toast with fries and nacho cheese sauce. Chili could be added to the top. It also offered a dessert 'shoe.

The Horseshoe Hut

This Springfield food truck was open from 2014 to 2016. It served "walking horseshoes."

Horseshoe Hut food truck. *Horseshoe Hut.*

RESTAURANTS TO VISIT

(CREATE YOUR OWN HORSESHOE ADVENTURE)

he historic and well-publicized restaurants that serve horseshoes in Springfield are listed first. The rest of the Springfield restaurants that have horseshoes follow.

Charlie Parker's Diner

700 North Street
www.charlieparkersdiner.com

Charlie Parker's was part of the Horseshoe Quest in 2011. The diner was established in 1992 in a Quonset hut; the current owner Bill Pope is the sixth owner of the restaurant. In October 2007, Guy Fieri visited Charlie Parker's Diner to film an episode of *Diners, Drive-Ins and Dives* for the Food Network. The episode aired for the first time in March 2008 and has been shown repeatedly over the years. Since that time, Charlie Parker's Diner has received many other national and local awards and citations. It was featured in the *Chicago Tribune* (2009), WGN's *Skydives* (2010), *Wall Street Journal* (2010), *Food Network Magazine*, Best Breakfasts (2010), Popular Plates in *Quick Eats* magazine, (2011), and Best of the U.S. Top 125 Road Stops. Charlie Parker's also received a visit from Michael Stern of www.roadfood. com. He rates it as "one of the best" and memorable. He particularly liked the breakfast 'shoe.

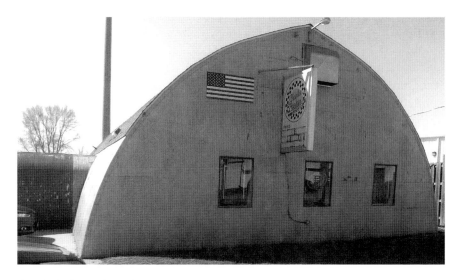

Charlie Parker's Diner. *Carolyn Harmon.*

Charlie Parker's Diner was named Grand Champion in the Thomas' Hometown Breakfast Battle, a contest with 135 restaurants from across the nation. Charlie Parker's Diner entered a breakfast horseshoe on an English muffin. After six weeks of online voting and a trip to New York City, where previous owner Mike Murphy cooked the breakfast horseshoe on *Fox & Friends* national morning show, Charlie Parker's was declared the National Grand Champion.

Horse and pony 'shoes have the usual choices with French fries or tater tots. There is also a chili cheeseburger available. Charlie Parker's was one of the first places to offer a breakfast 'shoe. It comes with gravy, cheese sauce or both. The menu says "ask for it like our Hometown Breakfast Battle National Champion" on a Thomas' English muffin.

Darcy's Pint

661 West Stanford Avenue
www.darcyspintonline.com

Darcy's opened in 1998 in the Town and Country Shopping Center. It moved to its current location in 2005. Hallie Pierceall and Glenn Merriman were the first to add different cheese sauces, which created

quite a stir. People can choose meat or veggies on Texas toast with "unforgettable" homemade cheese sauce. The choices are traditional (yellow), spicy (white) or a combination. Meats include ham, corned beef, turkey, bacon, hamburger, grilled chicken, Italian sausage, breaded tenderloin, roast beef, pastrami or walleye. Signature 'shoes include the Deluxe (seasoned ground beef with grilled onions and bacon bits), Chili Cheeseburger (hamburger patty topped with chili, scallions and traditional cheese sauce), the Supreme (seasoned ground beef with spicy cheese sauce, diced tomatoes, bacon, scallions and a side of hot sauce), the Irish Cheesesteak (sirloin piled high with mushrooms, onions, peppers and melted cheese) or a Chili Cheese Dog (quarter-pound gourmet all-beef hot dog topped with chili, scallions and traditional cheese sauce). The *Wall Street Journal* article mentions the "weekly horseshoe specials," including fried bologna, chicken liver and the "New Yorker," which adds corned beef to the pastrami. Sizes are the "pint" horseshoe or "½ pint" pony. The favorite, buffalo chicken, is served with sides of hot sauce and blue cheese dressing. Hallie Pierceall was one of the creators of an "Obama 'Shoe" in 2009.

Darcy's is usually the winner of the Best of Springfield (*Illinois Times*) and Reader's Choice (*State Journal-Register*) for horseshoes. It won the Trailblazer (for innovative) and People's Choice awards at the Springfield Parks Foundation Horseshoe Showcase in 2004. It also won the Crazy Horse 'Shoe and Classic 'Shoe at the 2009 World Horseshoe Cook-Off in 2009. (The Crazy Horse was awarded after Lindsay's entry caused controversy.) The Crazy Horse entry was mini cheeseburgers, bacon, tomatoes, pickles, onions, toast, cheese sauce and fries. Darcy's was also featured in the Horseshoe Quest 2011.

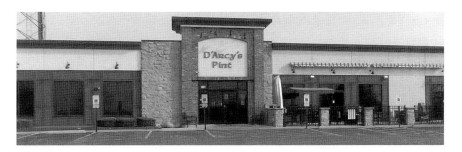

D'Arcy's Pint. *Carolyn Harmon.*

Darcy's horseshoes have been featured on television. YouTube videos from the Travel Channel include a *Man v. Food* segment from 2009 where Brian eats a breaded tenderloin 'shoe. The video showed several different 'shoes, including an enchilada 'shoe. Another Travel Channel video has Hallie Pierceall, one of the owners, talking about Darcy's having "the best horseshoe in Illinois in 2010." Al Roker visited Darcy's for a *Roker on the Road* segment in September 2004 for the Food Network.

Darcy's is also listed in *Road Food Sandwiches* by Jan and Michael Stern, along with the horseshoe recipe. Michael Stern rated Darcy's as "one of the best" and "memorable" on roadfood.com. D'Arcy's is also listed in *Eat & Explore Illinois* by Musgrove, although the horseshoe recipe is listed later in the book.

Dublin Pub

1975 West Wabash Avenue
www.springfielddublinpub.com

Dublin Pub opened in the space at Town & Country Shopping Center vacated by Darcy's Pint in 2005. The owner, Joe Rupnik, used two of his father's cheese sauce recipes. An article in the *State Journal Register* in 1999 tells about Joe's father, John Rupnik Jr., who was an "apprentice" chef at the Leland Hotel when Joe Schweska created the horseshoe. Dublin has great walleye and creative horseshoes, including a club BLT with chicken, bacon, tomato, lettuce and cheese sauce. Specialty 'shoes have included Philly steak, veggie, buffalo chicken, chiliburger, Italian sausage (which has been deleted), tenderloin, Reuben (corned beef, sauerkraut, rye bread and special Reuben sauce), "sweet breaded bacon chicken pony," slow roasted BBQ pork or pot roast. The regular 'shoes include corned beef, roast beef, grilled or breaded chicken, turkey, ham, bacon, hamburger, walleye, chili burger and veggie. There are three sauce choices: Dublin's white, pepper jack, and "The Leland Hotel Original Yellow." The pepper jack is Joe's special creation. Dublin is usually a finalist for the Best of Springfield (*Illinois Times*) and Reader's Choice Awards (*State Journal-Register*). It won the Big Cheese for its cheese sauce at the 2005 Springfield Parks Foundation Horseshoe Showcase. It also was part of the Horseshoe Quest 2011. Dublin Pub moved to its current location in 2010.

Jungle Jim's Café

1923 North Peoria Road
Facebook

Jungle Jim's Café.
Carolyn Harmon.

"Jungle Jim" and Mary Davison opened Jungle Jim's about 1988 on North Ninth Street. It moved to the current address in 1995. The Davisons describe their horseshoe as "the Northend's Finest" with choices of chili, hamburger, ham, turkey or bacon. Both locations were on historic Route 66. Their horseshoes are mentioned in *Recipes from Historic Route 66* by David Badger in 2010. No recipe was provided.

Maid-Rite Sandwich Shop

118 North Pasfield Street
www.maid-rite.com

Maid-Rite opened about the same time the horseshoe was created. The Springfield Maid-Rite was built in 1924 and joined the Maid-Rite chain in 1930 according to John Jakle and Keith Sculle in *Fast Food: Roadside Restaurants in the Automobile Age.* The Springfield store entered the National Register of Historic Places in 1984, partly because it is believed to have the first "drive-through" window. It is also located on historic Route 66, which was built around the same time. Burt Wolf visited the store in 2014 for a *Local Flavors* segment.

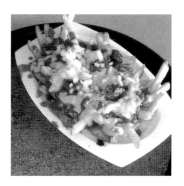

A Maid-Rite Sandwich Shop Horseshoe. *Carolyn Harmon.*

Sam Quaisi has owned and managed the Springfield Maid-Rite since 1986. He said the horseshoe is a "recent addition" to the menu and "has been very successful." It won the Trailblazer award for the most original horseshoe at the Springfield Parks Foundation Horseshoe Showcase in 2002. It also participated in 2005. Although the horseshoe does not show up on Maid-Rite's national menu, the Springfield store offers the ground beef Maid-Rite in the usual bread, fries and cheese sauce combination.

Maldaner's Restaurant and Catering since 1884

222 South Sixth Street
www.maldaners.com

Maldaner's is one of the oldest restaurants on Route 66 and Springfield's oldest restaurant. John Maldaner moved to Springfield with his mother and siblings in 1866, according to a 1920 article about him in the *Daily Illinois State Journal*. He worked at a confectioner's shop for about a year before becoming a pastry chef at the Leland Hotel. He started his own shop in about 1884. He was in partnership with Charles Frank for a while and relocated a couple of times before moving to 222 South Sixth Street in 1898.

According to a file in the Sangamon Valley Collection at Lincoln Library, John's son, Charles, began working with him in 1902. It was not until after a fire next door in 1911 that the restaurant was created. The fire required a new interior be constructed.

Walter Tabor began working for Maldaner in about 1907. After John died in 1924, Walter and Charles worked together until Charles died in 1934, when Walter took full ownership. He expanded the restaurant and continued

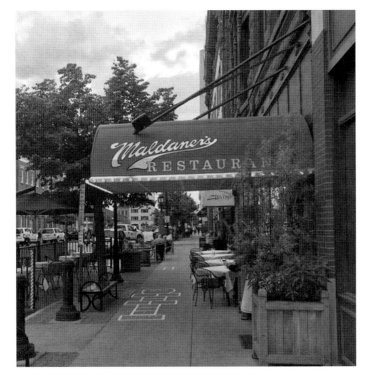

Maldaner's Restaurant. *Carolyn Harmon.*

to be involved until he died in 1971. His daughter, Betty Woods, took over until Carolyn Oxtoby purchased the building and restaurant.

Carolyn Oxtoby acquired the building in 1977. Much of the block was originally built by her grandfather George Pasfield Jr. She remodeled the building and purchased the restaurant. Leroy and Shirley Pisani managed Maldaner's from 1978 until Michael Higgins became the owner in 1995.

When Michael Higgins took over as chef in 1982, he tried to eliminate horseshoes from the menu. He put them back on pretty quickly according to a newspaper article. Maldaner's typical horse or pony 'shoe includes hamburger, bacon, ham or chicken breast on Texas toast with French fries and Maldaner's rarebit cheese sauce. President Obama worked as an Illinois state legislator in Springfield, so Higgins created a special Obama 'shoe in November 2009. Maldaner's horseshoe was featured on a Food Channel video in 2017 and a *Midwest Living* magazine "Springfield Trip Guide." There also is a YouTube video, and Maldaner's was part of Horseshoe Quest 2011.

Ritz's Lil Fryer/Ritz's West

2148 North Grand Avenue East/700 West Jefferson Street
Facebook

Kurt Ritz had access to the original horseshoe recipe thanks to Wayne Coumbes according to an article in the *State Journal-Register*. He told Michael Stern that cheese is the most important part of the 'shoe in an interview on www.roadfood.com. He said he adds Old English cheese and milk to the roux each morning. Photos of Ritz's 'shoes can be found at www.roadfood.com along with the rating of "good, worth a return." They are also highlighted in the Stern book *500 Things to Eat Before It's Too Late*. Ritz's offers a breakfast horse or pony 'shoe with hash browns or American

Ritz's Lil Fryer.
Carolyn Harmon.

fries, cheese sauce and/or sausage gravy. The lunchtime horse or pony 'shoe has the usual choices, plus veggie burgers, shrimp or fish. American fries, hash browns, onion rings, tots, mushrooms, tomatoes or extra cheese can be requested. Ritz's is often a runner-up for Best of Springfield (*Illinois Times*) and the *State Journal-Register*'s Reader's Choice for horseshoes.

Route 66 Mother Road Diner (formerly Yesterdays)

Located inside the Route 66 Hotel and Conference Center,
625 East St. Joseph Street
www.66motherroaddiner.com

This restaurant recently replaced another restaurant in the Route 66 Hotel. The breakfast horseshoe has ham, bacon or sausage with two eggs, hash browns and gravy or cheese sauce. The "Route 66 Shoe" choices include hamburger, turkey, ham, grilled or buffalo chicken, chicken tenders, bacon and tomato, Philly cheese steak or pork tenderloin on Texas toast with homemade cheese sauce. Route 66 brought the Philly cheese steak horseshoe with onions, green peppers and the expected fries and "homemade cheese sauce" to 'Shoes & Brews in 2017.

Route 66 Mother Road Diner in the Route 66 Hotel & Conference Center. *Carolyn Harmon.*

Steak 'n Shake

1580 Wabash Avenue, 2465 North Dirksen Parkway, 3184 South Dirksen Parkway, 4211 Conestoga Drive (and 1960 West Morton Avenue, Jacksonville, IL) www.steaknshake.com

According to the book *Fast Food: Roadside Restaurants in the Automobile Age*, Steak 'n Shake began in Springfield in 1939. The local franchises in Springfield and Jacksonville probably began serving horseshoes about 1975. Lutz Corra was the cheese sauce creator "in the fashion of the Leland Hotel." Steak 'n Shake won Honorable Mention in 1993 and Preferred 'Shoe in 1994 at the Springfield Parks Foundation Horseshoe Showcase. A Steak 'n Shake ad says "Home of the Horseshoe: It's a Springfield Tradition" (at participating locations). A new restaurant is supposed to open in Taylorville, Illinois, in 2019 that will also serve horseshoes.

Steak 'n Shake. *Carolyn Harmon.*

NEWER RESTAURANTS

411 Bar & Grill

411 East Washington Street
Facebook

The 411 has a "Lane Splitter" horse or pony 'shoe. The usual choices include Humphrey's ground chuck. It has the story of the horseshoe from Wikipedia in its menu. (Wikipedia has since updated the information.)

Abe's Hideout & Saloon
(Springfield and Mechanicsburg)

2301 South Dirksen Parkway, Springfield/ 200 West Main Street,
Mechanicsburg
Facebook

The first restaurant started in Mechanicsburg in 2009, with the Springfield location opening in 2014. It has the usual meat choices with homemade cheese sauce and seasoned fries. The Abe's in Mechanicsburg is located in a historic building. Both received runner-up Abe Awards (teens) for horseshoes in 2016 and 2017.

Alamo, Alamo II

115 North Fifth Street, Springfield, 310 North Main Plaza, Chatham, IL
Facebook

The Alamo has been in downtown Springfield since 1972 but moved to the current location in 1997. A second "Chalamo" opened in Chatham in 1996. They offer a 'MO SHOE (Mexican Style Horseshoe), a bun with hamburger, chicken filet, shredded chicken, spicy chicken, pork tenderloin or Italian beef covered with chili, French fries and Mexican-style cheese sauce. A 'MO PONY is also available. The Alamo won the overall Golden 'Shoe award at the Springfield Parks Foundation Horseshoe Showcase in 2004 with a spicy Mexican cheese sauce. The Alamo II won the 2005 Trailblazer award for the most original.

Andy's Snack Bar

2621 West White Oaks Drive
Facebook

Andy's opened in 2018 and has horseshoes on the menu.

AZ-T-CA Mexican Grill

2753 Chatham Road and food truck
Facebook

The restaurant has a one-size horseshoe.

(The) Barrel Head

1577 Wabash Avenue
www.thebarrelheadspringfield.com

The Barrel Head opened in 1974. It offers a Loaded Barrel horseshoe, which includes meat, bacon bits, tomatoes, green onions and chipotle sauce. The Barrel Head Chili 'Shoe has a certified Angus beef patty, chili, barrel bites (tater tots), red onions and cheese sauce. The classic is the usual meat, fries and homemade cheese sauce. The Barrel Head won the Big Cheese for its cheese sauce at the Springfield Parks Foundation Horseshoe Showcase in 2002 and was a "Reader's Choice" finalist.

Bernie & Betty's Pizza and Fine Food

1101 Spring Street
Facebook or springfield-vr.com/033.html (a virtual reality tour)

Bernie & Betty's opened in the 1960s. After moving a few times, it has been in its current location since about 1988. The owners describe their horseshoe as "award-winning" on the menu, which offers the usual choices, but you can add extra cheese. Bernie & Betty's won the Golden 'Shoe in 1993 at the Springfield Parks Foundation Horseshoe Showcase. When it won the Trailblazer award in 1994, it had shrimp and tomato, fried chicken, Italian beef and vegetable 'shoes according to an article in the *State Journal-Register*. Bernie & Betty's was on the Horseshoe Quest 2011.

Blue Margaritas Mexican Bar & Grill

3151 Horizon Drive
www.bluemargaritas.com

Blue Margaritas has an "American Horseshoe" composed of a flour shell with chicken breast, fries, pico de gallo and cheese sauce.

Boones Saloon

301 West Edwards Street
www.boonessaloon.com

Boones opened in 1983 with a western theme. It's no surprise the owners would put horseshoes on the menu. You can choose the house cheese sauce or the house white queso sauce, which is spicy. Added to the usual choices are black bean burger, veggie, jalapeno or smoked applewood bacon. Interestingly, Boones doesn't have a pony 'shoe choice. It won the Big Cheese award at the Springfield Parks Foundation Horseshoe Showcase in 2004 and the Golden Award for best 'shoe in 2005.

Boyd's New Generation

1831 South Grand Avenue East
Facebook

Boyd's has a one-size hamburger horseshoe on the menu.

Brewhaus

617 East Washington Street
Facebook

The Brewhaus is now Frankie's Brewhaus. The Brewhaus opened in 1994 and won the Big Cheese award in 1995 at the Springfield Parks Foundation Horseshoe Showcase. In 1997, it won for the most innovative 'shoe with pork in Jamaican jerk sauce. In 1998, the Brewhaus won both the People's Choice award and best French fries. It currently offers the usual choices of 'shoes.

Brickhouse Grill & Pub

3136 West Iles Avenue
www.brickhousegrill.net

Brickhouse 'shoes can include black bean chipotle burgers, turkey burgers, a Kobe burger as well as the usual choices. It also has an "Ultimate Shoe" that includes a burger, bacon, ham and turkey topped with cheese sauce, fries and diced tomatoes and green onions. Brickhouse opened in 2009, and in 2011, it won the *Illinois Times* Best Bar Food for the westside and downtown locations. The downtown location closed in 2016.

(The) Bunker Bar & Grill

933 North Grand Avenue West
Facebook

The Bunker is a relatively new place near the Army National Guard base. It offers the typical choices with one size of 'shoe. When asked what makes the 'shoes special, a waiter said the cheese sauce, which is homemade.

(The) Burger Bar and Backdoor Lounge

2765 South Sixth Street
Facebook

The Burger Bar has horse and pony 'shoes with the usual choices. It was a finalist for the Reader's Choice (*State Journal-Register*) Horseshoe in 2018.

Cancun

3028 Stanford Avenue, 420 South Crossing Drive, Sherman, IL
Facebook

Cancun's Mexican horseshoe is a quesadilla with grilled chicken or beef, fries and cheese sauce topped with lettuce, tomato and sour cream.

Capital City Bar & Grill

3149 South Dirksen Parkway
Facebook

Capital City opened in 1993. Along with the regular meat choices, it offers "specialty" horse and pony 'shoes of Italian beef, buffalo chicken, tenderloin or walleye. The fries are either waffle or "fair fries."

Casey's Pub

2200 Meadowbrook Road
Facebook

Casey's horseshoes have "crisp seasoned fries" and "house cheese sauce."

Chaditos Mexican-American Grill

3030 South 6th Street, 6490 North Walnut Street Road and a food truck
www.chaditos.com

Chaditos started as a food truck, which the owners still have. It offers several horseshoe choices, including a Mexican horseshoe.

Char House

2500 Sunrise Drive
www.springfield-charhouse.com

Char House has a one-size horseshoe with the usual meat choices.

Clubhouse at Long Bridge Golf Course

1055 West Camp Sangamo Road
www.longbridgegc.com/clubhousemenu

The restaurant opened in 2011 offering "Golf Shoes." Besides the usual offerings, it has a black bean horseshoe, a club 'shoe of ham, turkey and bacon with diced tomatoes on the top and a bourbon burger 'shoe. The

hamburger 'shoe includes grilled onions and mushrooms "smothered" in bourbon sauce topped with blue cheese crumbles.

Cook's Spice Rack and Chili Company

910 West North Grand Avenue
www.cookspicerack.com

Cook's has "Famous" horseshoes on the menu. The breakfast one is an egg 'shoe. Lunch 'shoes have the usual choices plus chili (no surprise since it's a chili company) or gyro. Chili can be added to the top of any 'shoe. The menu specifically mentions the kitchen can accommodate "other special requests."

Cooper's Alleyside opened at King Pin Lanes in 2017, Cooper's StrEATside Bistro food truck since 2013.

3115 Sangamon Avenue
www.cooperstreatside.com or www.toasttab.com/coopers-alleyside

Cooper's has a "Coop's Shoe Boat" with pulled pork, grilled, chopped chicken, grilled steakburger, breaded or buffalo chicken, tofu or roasted veggies on top of hand-cut jack 'o fries with Coop's cheesy sauce, Tiger Sauce and pico de gallo. There also is a "Pork and Rice Boat" or a "Build Your Own Boat." A build-your-own "breakfast boat" was added to the menu in December 2017. With a choice of pancakes, biscuits, fries or hash browns, it wouldn't have all the horseshoe components. There is the necessary cheese sauce or sausage gravy, though. Cooper's had a chorizo 'shoe with "Coop's Cheese Sauce," a hamburger 'shoe and a dessert horseshoe with sweet and spicy tortilla strips with whipped cream, caramel and chocolate shavings at 'Shoes & Brews in 2017.

Corner Pub & Grill

3271 West Iles Avenue
www.thecornerpubandgrill.com

Since opening in 2006, the Corner has offered the usual horseshoes. It also has a gyro or roast pork horseshoe. Diced tomato, grilled onions, mushrooms, scallions and extra cheese can be added. Sweet potato or waffle fries can also be substituted for regular fries. The interesting addition is the Horseshoe Pizza. It uses cheese sauce instead of tomato with thin-cut fries, the usual meat choices and shredded cheese on the top. It comes in a seven or twelve inch.

Cousin Eddie's Sports Bar & Grill

1951 West Monroe Street
www.cousineddies.net

Cousin Eddie's opened in Fairhills Mall in 2012. It has "Marty Moose Shoes" with house white cheese sauce and the choice of fries or tots. Along with the usual meat choices it offers a sloppy joe, jalapeno bacon or rib eye 'shoe.

Coz's Pizza and Pub

4441 Ash Grove Drive
www.cozspizzaandpub.com

Coz's offers eleven protein choices, including grilled portobello mushroom, in a one-size 'shoe with waffle fries and "smothered in our cheese sauce." Chopped green onions can be added to the top.

(The) Curve Inn

3219 South Sixth Street Road
www.curveinn.com

The Curve Inn was first Copp's Corner in 1932. Owners changed, but the name change of the Curve Inn (named because it was on a Route 66

curve) has continued since 1945. The dive bar has an interesting history according to its website. It bills itself as "Springfield's Original Roadhouse." The horseshoe is made with the meat from a local grocer, Humphrey's. Choices include hamburger, rib eye, grilled tenderloin, grilled chicken, fried chicken breast, bacon, chili hamburger, ham, buffalo chicken breast, Italian beef, BBQ or garlic pulled pork or sliced turkey. Bread, fries and Monterey cheddar cheese sauce complete the meal.

Delaney's Bar & Grill

2249 North Third Street
Facebook

Delaney's offers the usual horseshoe choices.

The Dew Pub & Grill/ The Dew Parlor

301 North Grand Avenue West, 2690 South Dirksen Parkway,
2312 Wabash Avenue
Facebook

The Dew has been a chilli parlor since 1909. When purchased by John Leskovisek and Mike Monseur in 2017, it moved from the original location, and the menu expanded to include horseshoes. All three locations have "Dew Shoes" with Dew cheese and Dew Flat Fries. The Pub & Grills have more meat choices. (The North Grand location is where the historic Wayne's Red Coach was located.)

DJ's Café

915 West Laurel Street
Facebook

Previously known as D&Js when it opened in 1974 at 901 West Laurel, the café changed name and location in 1997 when it moved to 915 West Laurel. It offers a choice of burger, ham, smoky bacon, pulled pork, tenderloin, grilled or fried chicken, fried walleye, Reuben, muffaletta, shaved prime

rib or chiliburger with house-made cheese sauce and hand-cut fries or tots. Michael Stern of www.roadfood.com rates the breakfast 'shoe as "one of the best" and "memorable." The Sterns also have D&J listed in *500 Things to Eat Before It's Too Late.*

Engrained Brewing Company

1120 West Lincolnshire Boulevard
www.engrainedbrewing.com

Engrained opened in 2013. It has made an effort to be "sustainable" and uses farm-to-table, locally sourced food. It offers a horse or pony 'shoe with the usual meat choices, hand-cut fries and house-made cheese sauce with scallions on the top. Bacon or a fried egg can be added to the meat choice.

Finley's Tap House

3236 Ginger Creek Drive
www.finleystaphouse.com

This newly opened gastropub, with chef Chip Kennedy, offers the usual horse or pony 'shoe meat choices along with something called "hot chicken." The 'shoe is on "toasted beer bread," with house-made fries and Finley's beer cheese sauce.

Fox Run Restaurant and Lounge

1130 Legacy Pointe Drive
www.foxrunrestaurantandlounge.net

Fox Run opened in 1980. Keith and Lisa Ayre are still involved along with their daughters, Nicole and Jaime, who are managers. After three other locations, it settled at Legacy Pointe. Fox Run has 'shoes with hand-cut fries or tater tots (or a combination of fries and tots). The house-made cheese sauce is put on before the potatoes. Along with the usual meat choices, muffaletta, chili burger, Reuben or shaved prime rib are listed on the menu. Special requests like a vegetarian horseshoe are also accommodated. They have been a "Reader's Choice" finalist.

Fritz's Wagon Wheel

2709 South MacArthur Boulevard
Facebook

The Wagon Wheel opened in 1949 on Wabash Avenue. Fritz Havrilka purchased it in 1969, and the name stayed the same, even after he was killed during a burglary in 1982. His wife, Nancy, took over for a while but then sold it to Joe Bart in 1993, according to a *State Journal-Register* article. Fritz's has been serving the usual 'shoes for a long time. It does have an egg 'shoe. Ham, turkey or bacon can be added to it. It also offers a University of Illinois 'shoe of chopped sirloin, mushroom, tomato and bacon.

Fulgenzi's Pizza and Pasta

1168 Sangamon Avenue
www.fulgenzis.com

Jeff Fulgenzi opened a Custard Castle restaurant in 1979. Fulgenzi's offers a horse or pony 'shoe with cheddar or white cheese sauce. A "California" horse or pony has a special cheese sauce and costs more. Some meat choices also cost more. They also have some Route 66 history located on-site. Mahan's Filling Station, which was part of Shea's Route 66 Museum before it closed, is now next to the restaurant. It is one of the oldest filling stations in the state. According to the *Illinois Route 66 Visitor's Guide*, the restaurant was once the site of Route 66 motels and a "car painting business" and has become "a regular stop for Route 66 travelers."

Gabatoni's

300 East Laurel Street
www.gabatonispizza.com

Gabatoni's opened in 1951, near Route 66. Since it is a pizza place, it offers pepperoni, sausage and veggie 'shoes of one size.

George Rank's

1800 South Sixth Street
www.georgeranks.com

Originally opened in 1974 on Historic Route 66, George Rank's offers a one-size horseshoe with hamburger, black bean burger, chicken, fish or chili cheeseburger. The fries are "criss-cross," waffle fries, which some people prefer.

Grille at City Centre

700 East Adams Street
www.grilleatcitycentre.com

When the Hilton was sold and became Wyndham Springfield City Centre, the restaurant became the Grille at City Centre in 2015. The menu offers "comfort food" and suggests patrons go for the horseshoe: "Try a Springfield Classic." The choices are the usual or a vegetable patty. The cheese sauce is "signature."

Gyros Stop

2907 South MacArthur Boulevard, 4127 Wabash Avenue,
2345 West Monroe Street
Facebook

Gyros Stop offers a variety of 'shoes, including a gyro 'shoe with cucumber sauce, tomato and onion. The Western has tomato, spicy BBQ, grilled green peppers, onions and feta cheese. There are several types of chicken, a quarter-pound hamburger or tenderloin. All 'shoes have a choice of white or yellow cheese sauce. There is a smaller size kids' 'shoe along with the regular size.

Hickory River Smokehouse

2343 North Dirksen Parkway (1706 North Cunningham Avenue, Urbana, IL; 2330 South Mt. Zion Road, Decatur, IL; 5101 West Holiday Drive, Peoria, IL) www.hickoryriver.com

The four Hickory River locations in Central Illinois offer "Our Famous 'Cue Shoe" of "BBQ pulled pork & fries on 'big bread' smothered in Hickory River's special cheese sauce with BBQ sauce on the side." Other meat choices can be substituted. (The Ohio locations do not have horseshoes on the menu.)

Homestyle Café

*1144 North Ninth Street
Facebook*

The Homestyle has served 'shoes since about 2003. It offers the usual choices or a breakfast 'shoe with hash browns. Biscuits can be substituted for toast, and gravy or homemade cheese sauce is poured on the top.

Island Bay Yacht Club

*76 Yacht Club Road
www.ibyconline.com*

The yacht club has had horseshoes since at least 1993, when it participated in the first Springfield Parks Foundation Horseshoe Showcase. Island Bay also participated in 1996, 1998 and 2000. It won the People's Choice award in 1997. "Springfield 'Shoes" still appear on the menu with "house made cheese sauce." Horse or ponies with Black Forest ham, turkey, hamburger, grilled or breaded chicken, bacon or vegetable and fries or tater tots are available for members.

Izzy's Café

520 West Washington Street
Facebook

Open since 2008, the café offers the usual meat choices in its pony 'shoe. Walleye is available on Friday.

Joseph's Fine Cuisine

3153 Hedley Road
www.chefjojocorp/josephs

Its horseshoes have the choice of fries or tater tots and a Kobe meat option.

JT Costello's Pizza Pub & Grill

7024 Kingsmill Court and 518 Bruns Lane
Facebook

JT Costello's was opened in 2011 by the family of Coz's Pizza and Pub. It offers the usual horseshoe choices with "JT's homemade beer cheese sauce."

Keefner's Sandwiches, Suds & Stories

1941 West Iles Avenue
Facebook

Angie Keefner-Grieser opened Keefner's in 2015 in memory of her father, who owned Bachmann-Keefner Drugstore in downtown Springfield from 1974 to 1989. The "cold sandwich" menu comes from the soda fountain at the old drugstore, which opened in 1912. After changing names several times, it finally closed in 2004. The décor reflects the history of the old drugstore, which was on Route 66. Bachmann-Keefner Drugstore was across the street from the Leland Hotel, the horseshoe's birthplace. According to the menu, Keefner's has a "6 Degrees Take on our Springfield Sandwich" with the usual meat choices as well as catfish, mushroom and meatloaf. The horse or

pony 'shoes have "delicious Welsh rarebit white cheese sauce topped with golden shoe string fries." The name *6 Degrees* comes from Angie's youngest sister, Ann, who is the owner of 6 Degrees Restaurant in the Chicago Bucktown area. It is one of the few Chicago restaurants that has horseshoes on the menu. (There is more about 6 Degrees in chapter 5.) Keefner's was a Best of Springfield *(Illinois Times)* and *State Journal-Register* Reader's Choice finalist for horseshoes. Several people said they really like these horseshoes on Facebook.

Koo Koo's Nest

3045 Sangamon Avenue
Facebook

Koo Koo's Nest has the usual horseshoes.

La Fiesta Grande/La Fiesta Chatham

2830 Stevenson Drive/ 6901 Preston Drive
www.lafiestagrande.us

La Fiesta brought a Mexican horseshoe to the 2017 'Shoes & Brews, and it is now on the regular menu. This version is a tortilla covered in chicken or steak strips with fries and La Fiesta Grande's queso cheese sauce.

Lake Pointe Grill

1386 Toronto Road
www.lakepointegrill.com

Lake Pointe has been serving horseshoes since it opened in 2008. It offers a "white cheddar ale rarebit cheese sauce" with sourdough Texas toast slices topped with hand-cut russet fries and the usual meat choices. Lake Pointe also has a kid's 'shoe.

Lake Springfield Tavern

1221 Stevenson Drive
Facebook

Lake Springfield Tavern has an assortment of twelve different "You're Hooked Horseshoes" with homemade white cheese sauce and the usual meat choices. It also has poor boy, walleye and bacon with tomato 'shoes. Pony 'shoes and a "Triple By-Pass 'Shoe" (a hamburger 'shoe topped with chili and shredded cheese) are also available.

Lime Street Café

951 South Durkin Drive
Facebook

Lime Street moved into the Same Old Shillelagh spot in 1989. It has "Shoe Your Own" horseshoes with "our own cheese sauce," rye toast and "natural" fries. Along with the usual choices, shrimp is an option. Lime Street was on the Horse 'Shoe Quest in 2011.

Lindsay's Restaurant/The Globe Tavern

701 East Adams Street
www.doubletree3.hilton.com

Lindsay's and the Globe Tavern have been located in the President Abraham Lincoln Hotel and Conference Center since 1985, when the hotel was a Ramada Renaissance. Financial issues caused the sale of the hotel between 2007 and 2009. It became the President Abraham Lincoln Hotel Springfield, a DoubleTree by Hilton in 2013. Lindsay's was originally Lindsay's Gallery, named after Springfield author Vachel Lindsay. The Globe Tavern was named after the Lincoln-era Globe Tavern. The hotel website mentions the hamburger horseshoe, which it has offered since it opened. Lindsay's was involved in horseshoe controversy in 2009 when it competed in the first World Horseshoe Cook-Off, which coincided with the World Horseshoe Pitching Championship in Springfield. Lindsay's won three of the four categories for a horseshoe made of brioche, filet mignon, crab meat, sweet

potato fries and Cajun cream sauce. Lindsay's used its nearby kitchen while the other competitors followed the rules and assembled their 'shoes at the Prairie Capital Convention Center, the location of the event. Lindsay's kept the award for best 'shoe but other restaurants were given the "crazy 'shoe" and "breakfast 'shoe" prizes. Lindsay's was on the Horseshoe Quest in 2011. Horseshoe creations have recently moved from Lindsay's (which only serves breakfast now) to the Globe Tavern (which serves lunch and dinner).

Los Rancheros Taco Joint

230 ½ South Grand Avenue East
Facebook

Although the regular Los Rancheros restaurants do not have horseshoes, the new Taco Joint does. A one-size 'shoe is available with chicken, asada (steak), al pastor (pork) or brisket.

Lulu's Diner

608 South Ninth Street
Facebook

Lulu's has reopened with new owners. It offers a Mediterranean menu, which includes a gyro horse or pony 'shoe. Other choices are the usual meats, rib eye or veggies with the "house cheese sauce."

Mama Lee's Sandbar

6111 Mechanicsburg Road
Facebook

Although the address is listed Springfield, it is close to Riverton, Illinois. At least one person thinks Mama Lee's horseshoes are the "best" on a Facebook page.

Mariah's Restaurant

3317 Robbins Road
www.mariahsrestaurant.com

Mariah's offers a one-size 'shoe with the usual meat choices. It also has sausage and meatball 'shoes. Extra cheese sauce, sautéed onions and/or peppers can be requested.

Mario's Italian Restaurant & Pizzeria

3073 Clear Lake Avenue, 2841 Mansion Road
www.eatatmarios.com

Mario's has an "Italian 'Shoe" of toasted bread, homemade cheddar cheese sauce with pepperoncini "thrown on the side." Along with the usual meat choices, it offers Italian beef or sausage, meatballs, wings or fish.

Mess Hall (New Mess Hall) Restaurant

1120 Sangamon Avenue
www.springfieldamericanlegion.com/messhallrestaurant.htm

Located in Springfield American Legion No. 32, this restaurant offers a limited number of choices of meats on its 'shoes. Walleye is available on Friday. Suzie Weiss came out of retirement in 2018 to bring her "signature cheese sauce" from Suzie Q's to the horse and pony 'shoes.

MJ's Fish and Chicken Express

716 East Enos Avenue
Facebook

Located in the old Susie Q's, MJ's has hamburger, pork tenderloin, rib eye or walleye horse or pony 'shoes.

Nickey's Southern Style Kitchen

330 South Grand Avenue East
Facebook

Nickey's has one-size pony 'shoes with queso or avocado cheese sauce. Meat choices include a veggie burger, steak or pulled pork. (The avocado cheese sauce is very good.)

Nico's Homestyle

751 South Durkin Drive
www.nicoshomestyle.com

Nico's has a one-size horseshoe with "house made white cheese sauce." Traditional meat choices are supplemented with turkey burger or corned beef.

Obed & Isaac's Microbrewery & Eatery

500 South Sixth Street, Springfield; 321 Northeast Madison Avenue, Peoria
www.connhospitalitygroup.com

Obed & Isaac's is located in historic Springfield and Peoria buildings that have been restored. Springfield's Obed and Isaac's opened in 2012 on a lot owned by the Conn family. Peoria's location opened in 2016 in a restored church. The horse or pony 'shoe is listed as a "Springfield Original" on the menu. Choices of meat include a veggie burger, lamb burger or corned beef as well as the usual offerings. The restaurants use a "secret cheese sauce," and the fries are placed on the top after the sauce. They also have a breakfast 'shoe on their Sunday brunch menus. It is a buttermilk waffle topped with a breakfast meat and potatoes with two eggs smothered in gravy or cheese sauce. Obed & Isaac's has been a runner up for the "Best of Springfield" (*Illinois Times*) horseshoe. Richard Paul Evans described the horseshoe as a "heart attack sandwich" and said "he loved every bite" in his book *The Forgotten Road*.

(The) Office Sports Bar and Grill

1919 West Iles Avenue
Facebook

The Office Sports Bar and Grill was previously the Office Tavern on the east side of Springfield. The original Office Tavern opened in 1944 according to an article in the *State Journal-Register* in 1997. It moved to Montvale Plaza in 1997. The same article said the restaurant had the usual meat horseshoe choices and French fries or tater tots. The Office offered traditional horseshoes as well as a Clydesdale triple horseshoe and won the No Small Fry award for the best French fries at the Springfield Parks Foundation Horseshoe Showcase in 2002. A car crashed through the front door in 2016. It reopened a few doors down without the Clydesdale. At least one person felt the Office's 'shoe was the "best" on a horseshoe page.

Parkway Café (Leann's Parkway Café)

2715 North Dirksen Parkway
www.eatparkway.com

The Parkway Café has been open since 1993. It offers a breakfast 'shoe with a biscuit, sausage patty, sausage gravy, two eggs and American fries. It also has a traditional horseshoe with the usual meat choices. There is a "Big Ox" with three one-third-pound ground sirloin patties (one pound), three pieces of Texas toast, "special cheese sauce" and Idaho French fries. The "Parkway Chili 'Shoe" is a "hamburger served on an open toasted bun and then smothered with two ladles of our zesty chili. We then top it off with a blend of shredded cheddar and Monterey Jack cheese and diced onions and French fries."

Qdoba Mexican Grill

2320 Wabash Avenue
www.qdoba.com

Qdoba introduced its "Q 'Shoe" at 'Shoes & Brews in 2017. This bowl comes with tortilla shell pieces, rice, beans, meat and Qdoba's "awesome" queso cheese sauce. The menu says it has "customizable" food.

Route 66 Motorheads Bar & Grill

600 Toronto Road (Toronto Road at Interstate 55)
Facebook

Opened in the spring of 2018, Motorheads has Historic Route 66 memorabilia throughout the restaurant. It has the usual horseshoe offerings as well as a "morning 'shoe."

Secret Recipes Catering

3086 Normandy Road
www.secretrecipescatering.com

Secret Recipes is a catering company with a reception center. It offers the "Horseshoe Spoon" appetizer at Abraham Lincoln Presidential Library and Museum events. It also has a "Horseshoe Bar" as a catering choice. Secret Recipes served the Horseshoe Spoon at the Springfield Chamber of Commerce's first 'Shoes & Brews in 2017.

Sgt. Peppers

3141 Baker Drive
www.sgt-peppers-cafe.com

Sgt. Pepper's opened in 1999 on the west side of Springfield after a Lums fire in 1995. The current location opened in 2002. It has horse or pony 'shoes with either spicy white or yellow cheese sauce. Along with the usual, it offers specialty 'shoes, including steak or chicken fajita, cod, BBQ chicken or corned beef and sauerkraut (Reuben). The breakfast pony is the usual with hash browns or country potatoes and a choice of gravy or cheese sauce. Bacon or chili can be added to the top. Sgt. Pepper's also has an Edwardsville, Illinois location.

Silver Sevens Gaming Pub and Parlor

3217 Lake Plaza Drive
Facebook

Silver Sevens has the usual meat choices in a horse or pony 'shoe.

Sportsman's Bar & Grill/Lounge

229 West Mason Street
www.sportsmans-lounge-springfield.com

Sportsman's original 'shoes have the usual choices. It won the No Small Fry award in 2004 and 2005 at the Springfield Parks Foundation Horseshoe Showcase.

Stadium Sports Bar

2300 North Peoria Road
Facebook

Stadium has horse or ponies with the usual meat choices plus Cajun pork or chicken and bacon. There also is a prime rib pony 'shoe special on certain days.

Star 66 Café

3252 Camp Butler Road
www.star66cafe.com

Star 66 is on Route 66 near Riverton. It offers the usual horse or pony 'shoes along with a French horse or pony, a turkey and ham combination.

Statehouse Inn

101 East Adams Street
www.governorsballroom.com

Opened in 1961, there is a possibility the Statehouse created the smaller "pony 'shoe." The current Governor's Ballroom was constructed in 2010. Horseshoes are a choice on the catering menu by 5 Flavors. It is described as beef burger, buffalo tempura chicken, toast, shoestring fries and beer cheddar cheese sauce.

Sunrise Café (Hamburger Dan's Sunrise Café)

1201 South Second Street
Facebook

Sunrise Café offers the usual 'shoes, including a rib eye and walleye on Fridays. It won the 1997 Springfield Parks Foundation Showcase for fries and service. The café was visited by Michael Stern of www.roadfood.com and judged as "good, worth a return" along with a photo and review on the website.

Tasty City Seafood & Trio

4233 Wabash Avenue
www.tastycityrestaurant.com

Its Springfield #1 Sandwich is a horseshoe of beef, chicken or fish.

Top Cats Chill & Grill

3211 Sangamon Avenue
www.topcatschillandgrill.com

Top Cats offers the usual horse or pony 'shoe, including walleye. A Facebook review said the horseshoes with tater tots and pepper jack cheese sauce "are the best." It was on the Horseshoe Quest in 2011 and received the

People's Choice award at the 2005 Springfield Parks Foundation Horseshoe Showcase. Their horseshoe has been a finalist for the "Best of Springfield" and "Reader's Choice." The restaurant opened in 1999 and moved to its current location in 2015.

Track Shack

233 East Laurel Street
Facebook

Track Shack opened in the 1960s and has been serving the usual pony and horseshoes since. It was part of the Horseshoe Quest in 2011.

Trade Winds Pub & Eatery

1700 Knights Recreation Drive
www.tradewindspubandeatery.com

Located near Knights Action Park, Trade Winds was closed for several years and recently reopened. It offers the typical horseshoe of hamburger, ham, turkey, grilled or breaded chicken, grilled or breaded pork tenderloin, pulled pork or bacon with homemade cheese sauce. It offered a "The Captains's Chili Cheese Ponyshoe" for "Chili Week" in the fall of 2017. It also created a pony 'shoe for "Burger Week" in 2018.

Weebles Bar & Grill

4136 North Peoria Road
www.weeblesbarandgrill.com

Weebles has offered the usual horse or pony 'shoe choices since it opened in 2009.

Westwoods Lodge Pub & Grill

2406 West Jeferson
www.westwoodslodge.com

Westwoods offers "Snowshoes" in a horse or pony size as well as a kids' pony 'shoe. It has about twenty different meat choices, including clams, shrimp, chili and grilled veggies. Onion rings, criss-cut fries, pine cones (deep-fried mashed potatoes) or wood chips (fried thinly sliced potatoes) can be substituted for regular fries. It also has "specialty cheese sauces": Rajun Cajun, wild buffalo, cheesy bleu or chipotle. Wild side snowshoes include elk, bison, Wagyu beef burger, elk sausage, fried crawdads or fried gator meat choices. There is also the Yetti: "a massive snowshoe" with three Angus beef burgers topped with pulled pork or chicken strips for $17.99. It comes in a special plate shaped liked a large foot. A Yetti shirt and can cooler is available to purchase. Westwoods' 'shoes have been a runner-up for "Best of Springfield" (*Illinois Times*).

Yetti from Westwoods Lodge Pub & Grill. *Westwoods Lodge Pub & Grill.*

Yanni's Gyros

1814 Stevenson Drive
Facebook

Yanni's has offered pita 'shoes since 2007. Along with Italian beef, pork tenderloin and grilled chicken, there are regular gyros, chicken or barbecue gyros choices.

Food Trucks

B&W Good Eats & Treats has a walking pony 'shoe.

Mad Dog Concessions offers horseshoes or the "Xtreme 'Shoe."

EXPANDING INTO CENTRAL ILLINOIS AND BEYOND

When you have tried horseshoes at all the Springfield restaurants, there are more to try in Central Illinois. Bob Perry claimed credit for exporting the horseshoe beyond Central Illinois. The horseshoes that appear on the menus a distance from Springfield are the result of other Springfield transplants, including Ann Keefner, who brought the horseshoe to 6 Degrees in the Chicago Bucktown area. Her sister, Angie, has the 6 Degrees Horseshoe on Keefner's menu in Springfield. The Donovans carried the horseshoe to Georgia. The horseshoe and Maid-Rite have different names in Iowa. The listing begins with Central Illinois and moves to Chicago, Iowa, Texas, Arizona and even Georgia.

ALTAMONT, ILLINOIS

Luke's Bar & Grill

112 West Adams Avenue
Facebook

Luke's offers horse or pony 'shoes that have Texas toast topped with Swiss cheese, the usual meat choices, "house cut fries" and Monterey Jack cheese sauce on the top.

Schultz's Dairy Bar

600 South Main Street
Facebook

Schultz's traditional one-size 'shoe is available every day, while the Famous Pork Breaded Tenderloin 'shoe is only available on Tuesday. Photos are posted on the "Pursuing the Horseshoe Sandwich" page.

ALTON, ILLINOIS

Johnson's Corner

2000 State Street
www.johnsonscorneralton.com

Johnson's Corner offers a one-size "Golden Horseshoe."

ARTHUR, ILLINOIS

Yoders

1195 East Columbia Street
www.yoderskitchen.net

Even the Amish have horseshoes! Yoders has been serving Amish country for decades. Its "Horseshoe platter" (one size) is called a "local favorite." Choices are the usual meats with "cheddar cheese" (assuming sauce).

ASHLAND, ILLINOIS

Ashland Diner

200 West Editor Street
Facebook

Daily menu photos on a white board show horse and pony 'shoes as well as breakfast horse and ponies.

ASSUMPTION, ILLINOIS

Allen's 51

202 South Business 51
Facebook

Although a menu isn't posted, Allen's has Facebook photos of chicken strip and hamburger pony 'shoes with a choice of curly or crinkle French fries.

ATHENS, ILLINOIS

Boar's Nest Bar & Grill

1000 IL-29
boarsnestbarandgrill.com

The Boar's Nest has a breakfast horse or pony 'shoe with American fries, hash browns or tater tots and cheese sauce or gravy. There is a Shetland 'Shoe, which is smaller than a pony. It also has ponies, horseshoes and a Clydesdale. Regular meat choices include chili, while specialty meats include rib eye, Philly and Italian beef. Clydesdales are similar to those of other restaurants. It is four pieces of Texas toast, four servings of meat (customer's choice), fries and "Boar's Nest own cheese sauce" on a platter weighing over seven pounds. If it is eaten within one hour (the challenge), it is free and a photo is taken. It was also in the Horseshoe Quest of 2011.

ATLANTA, ILLINOIS

217 Roadhouse Bar-n-Grill

2005 2400th Street
Facebook

Located on the Old Route 66 bypass in a former Standard Oil gas station, it offers the usual one-size horseshoe.

Country-Aire Restaurant

606 East South Street
Facebook

Near Historic Route 66, it offers lunch and breakfast 'shoes. Lunch includes the turkey/ham combination that is sometimes called French. The "deluxe" 'shoe costs more than the "plain."

Palms Grill Café

110 Southwest Arch Street
www.thepalmsgrillcafe.com

Opened in 1934 on Historic Route 66, it offers horse and pony 'shoes on grilled sourdough with "House made smoked gouda cheese sauce."

AUBURN, ILLINOIS

Angie's Pasta & More

106 North Fifth Street
Facebook

Angie's opened in 2017 and offers a one-size hamburger or ham horseshoe.

AVON, ILLINOIS

Main Street Café

101 South Main Street
Facebook

The Main Street Café's horseshoe is "layers of toast and warm cheddar cheese" with the usual meat choices. Fry choices include regular French fries, waffle fries or seasoned waffle fries. Toppings available: mushrooms, tomatoes, onions, green peppers or jalapeños.

BARRINGTON, ILLINOIS

The Horseshoe Grill

28682 West Northwest Highway
www.thehorseshoegrill.com

The restaurant offers "El Horseshoe": a one-size hamburger 'shoe with "our creamy cheese sauce with crispy bacon crumbles."

BARTONVILLE, ILLINOIS

Local Grille & Bar

801 North McKinley Avenue
Facebook

Local has the "Local 'Shoe" or pony with the usual meat choices topped with chives. This 'shoe was in the list of "best" 'shoes on a horseshoe page.

BEARDSTOWN, ILLINOIS

Red Owl Restaurant

112 East Second Street
www.red-owl-restaurant.com

Red Owl offers the usual meat choices for its horse or pony 'shoes.

BELLEVILLE, ILLINOIS

Moore's Restaurant

7309 Old St Louis Rd
www.eatatmoores.com

Moore's was part of the competition with the St. Louis Horseshoe House in 2011. Operating since 1935, it offers a "Moore burger" of ground meat, which also is the meat in the horseshoe. Chili, nacho cheese and onions are put on top.

BLOOMINGTON-NORMAL, ILLINOIS

Maguires Bar & Grill

220 North Center Street
Facebook

Located on Route 66, it offers limited choices of horseshoe meats and just the one size.

Schooners

810 East Grove Street
www.schoonersbl.com

Schooners offers limited choices of horseshoe meats with one size.

Times Past Inn

1701 East Empire Street
www.timespastinn.com

Open since 1984, it offers the typical horseshoe choices.

Western Tap

1301 North Western Ave
Facebook

A person posted a photo of Western Tap's horseshoe on a Facebook horseshoe page.

CAHOKIA, ILLINOIS

Stingers Restaurant and Pizzeria

440 Falling Springs Road
www.stingersrt3.com

Stingers uses garlic Texas toast and "gooey cheese" on a one-size 'shoe.

CAMP POINT, ILLINOIS

Village Vineyard Winery

337 North Vermont Street
Facebook

Village Vineyard has horse or pony 'shoes. A person posted a photo on the "Pursuing the Horseshoe" Facebook page that shows cheddar and queso cheese sauce.

CANTON, ILLINOIS

American Grille

525 South Fifth Street
www.americangrille.biz

American Grille offers the usual choices of horse or pony 'shoes.

Billy's Tap

172 East Elm Street
Facebook

Billy's has the usual horseshoe choices.

Canton Family Restaurant

169 South Fifth Street
www.americanfamilyrestaurant.com

It has horse or pony 'shoes with the usual meat choices and "signature cheese sauce."

CARBONDALE, ILLINOIS

Pinch Penny Pub

701 East Grand Avenue
www.pinchpennypub.com

Pinch Penny's menu explains horseshoes and offers a variety, including fish and veggie 'shoes.

CARLINVILLE, ILLINOIS

Carlinville Plaza Café

170 Carlinville Plaza
www.toasttab.com/carlinville-plaza-cafe

Located just off Historic Route 66, it offers several meat choices and white or yellow cheese sauce on a horse or a pony 'shoe. There is a YouTube video from www.foodchallenges.com of the Monster 'Shoe Challenge: eat five large slices of Texas toast, five half-pound burgers, topped with two pounds of French fries, smothered with two pounds of cheese sauce in less than one hour. Prizes are a free meal and a picture on the "Wall of Fame."

(The) Refuge Coffee House Inc.

242 East Side Square
www.refugecoffeehouse.com

The Refuge has only a breakfast horseshoe.

Wood Duck Bar and Grill

546 West Main Street
Facebook

The Wood Duck offers a "famous" horseshoe in a single size. Along with the usual meat choices, there is a chili cheese hamburger 'shoe, Jon's Western 'Shoe or you can "turn anything into a 'shoe." The Western 'shoe has a BBQ-seasoned burger with BBQ sauce, bacon, onion rings and French fries.

CARTHAGE, ILLINOIS

(The) Wood Inn

415 Main Street
Facebook

The Wood Inn has a horse or pony 'shoe with the usual meat choices.

CHAMPAIGN-URBANA, ILLINOIS

Merry Ann's Diner

Two locations in Champaign (1 East Main Street, 1510 South Neil Street),
one location in Urbana (701 South Gregory Street) and one location in Normal,
Illinois (100 South Fell Avenue)
www.merry-anns.com

Merry Ann's has a one-size hamburger horseshoe "Diner Specialty." There also is a "Railsplitter" on the menu that sounds similar to a horseshoe with two whole-beef hot dogs, fries, chili and cheese sauce.

CHARLESTON, ILLINOIS

Smoky's House BBQ

300 West Lincoln Avenue
www.smokyshousebbq.com

Smoky's has several choices of "mule" or pony 'shoes that include BBQ sauce along with cheese sauce. Choices include pulled pork, brisket, smoked turkey, burger, buffalo chicken or "burnt ends."

WBs Pub N Grub

430 West State Street
Facebook

WBs has the usual horse and pony choices as well as a veggie.

CHANDLERVILLE, ILLINOIS

Butler's County Line

1116 State Route 78
Facebook

Butler's County Line offers horse or pony 'shoes with the usual meat choices. It also has pig fingers, pulled pork, beef brisket and tenderloin with a "homemade aged cheese sauce." At least one person thought the restaurant's 'shoe was the best on a Facebook horseshoe group.

Hollywood's Café

176 South Main Street
Facebook

Although a menu isn't posted, William Furry reported that the café has horseshoes in an article in *Illinois Heritage* magazine, July–August 2017. A photo is also provided on page 53 of the magazine.

CHATHAM, ILLINOIS

Chatham Café

414 North Main Street
Facebook

Chatham Café offers a breakfast horseshoe with sausage gravy. The single-size horseshoe is listed under burgers but has other choices such as roast beef, ham, turkey and chicken strips with the usual cheese sauce and fries.

(The) Creek Pub & Grill

1081 Jason Place
www.thecreekpub.com

The Creek 'shoes come in seventeen different choices with "house recipe cheese sauce." Options include veggie, walleye, shrimp and rib eye. It also has a kids' 'shoe of chicken strips or hamburger. At least one person thought the Creek's 'shoes were the best, according to a Facebook post.

Fat Willy's Bar & Grill

109 East Mulberry Street
Facebook

Fat Willy's, located just off Route 66, offers the usual horseshoes and a child-size "Shetland pony" 'shoe. It was included in the Horseshoe Quest 2011.

Scoop du Jour

95 West Plummer Boulevard
Facebook

It has an ice cream horseshoe!

CHENOA, ILLINOIS

Chenoa Family Restaurant

508 West Cemetery Avenue
www.chenoafamilyrestaurant.com

The restaurant has a Horseshoe Breakfast and horse or pony 'shoes for lunch with the usual meat choices and a French 'shoe with ham and turkey. It is located near Historic Route 66.

CHILLICOTHE, ILLINOIS

Castaways

1701 North Fourth Street
www.castawayschillicothe.com

It offers a horse or pony 'shoe with "Your Choice of: Burger, Ham, Pork Chop, Chicken Tenders, Turkey, or Grilled Chicken served on Texas Toast covered with Your Choice of: Signature Fries, Waffle Fries, Seasoned curly fries or tater tots, Smothered in Your Choice of: Yellow Cheddar or Monterey Jack cheese sauce."

Di's Downtown

1046 North Second Street
www.diandtomsdowntown.com

Di's has the usual meat choices in a one-size horseshoe. At least two people on a horseshoe Facebook page think Di's horseshoes are the "best."

Sliders Pizza & Pub

16002 North Second Street, Rome, IL (next to Chillicothe)
Facebook

One of the "Big Belly Burgers" is called the Illinoisan. The description is a horseshoe.

CLINTON, ILLINOIS

Ted's Garage

602 South Center Street
Facebook

The menu for Ted's Garage shows several choices of "Ted's Delicious Horsepower," including brake pads and a brake 'shoe, which are burgers, fries and queso on toast (the 'shoe is a smaller burger). The brake drum is chips topped with pork barbecue, queso and pico de gallo salsa. El Ranchero

is back to burgers and fries, with the queso and pico de gallo. The Tahoe has a special spot on the menu and costs a little more. It is a pork tenderloin with fries, queso and pico de gallo. Ted's is supposed to have the "Big Rig" challenge of a four-and-a-half-pound horseshoe in thirty minutes according to www.eatfeats.com.

COLLINSVILLE, ILLINOIS/O'FALLON, ILLINOIS

Horseshoe Restaurant & Lounge (Lounge & Restaurant)

410 Saint Louis Road/950 Talon Drive
Facebook

The Horseshoe in Collinsville reopened in 2014 in a historic building. (Collinsville is part of Historic Route 66 history.) A second location opened in O'Fallon in 2016. Along with the usual horse and pony 'shoes, they have an "I could eat a horse" 'shoe. It is nearly six pounds and made with homemade chili. If eaten within thirty minutes, it's free. There is a special "Red Bird 'shoe" of buffalo chicken. The fries are shoestring, and the cheese sauce is Monterey Jack.

CREVE COEUR, ILLINOIS

Hilltop Grill

Rusche Street
www.hilltopgrill.biz

Hilltop Grill has a one-size turkey, pulled pork, hamburger or tenderloin 'shoe.

DALTON CITY, ILLINOIS

Harleys Hideout

130 East Main Street
Facebook

Harleys has a "Custom 'shoe."

DANVILLE, ILLINOIS/TILTON, ILLINOIS/OGDEN, ILLINOIS

Rich's Deluxe/Rich's Family Restaurant

21 West North Street/ 2200 Georgetown Road/ 305 West Ellen Street
www.richsdeluxe.com/ Facebook/ www.richsrestaurant.com

Rich's one-size 'shoes are "A ringer every time." The usual choices of meats include the ham/turkey combination.

DAWSON, ILLINOIS

Gustos Pizzeria

10230 Old Route 36
www.gustospizzeria.com

Gustos has pony and horse 'shoes with homemade cheese sauce and the usual meat choices. Bacon or jalapeño bacon can be added as a garnish. At least one person thinks Gustos's 'shoes are the "best" on a horseshoe page.

PJs Dawson Lounge

101 Lewis
Facebook

PJs has horse and pony 'shoes with regular and specialty meat choices. Specialties include pork tenderloin, Philly cheesesteak, buffalo chicken, Italian beef and shrimp. There are "specialty fries" available for an extra charge. Some people on Facebook think PJs's horseshoes are the "best."

DECATUR, ILLINOIS

Doherty's Pub & Pins

242 East William
www.dohertyspubandpins.com

Dohert's offers a "Horseshoe Your Way." People can choose between hamburger, buffalo chicken, Reuben, pork tenderloin, ham, turkey, grilled chicken, ground beef or shepherds pie meat on rye, wheat or Texas toast with waffle or regular fries.

Fireside Grill

4191 US 36 in Hotel Decatur
www.hoteldecatur.com

The Fireside Grill has a regular 'shoe with the usual meat choices. It also has an "Ultimate Horseshoe" with an Angus beef patty, fries, cheese sauce, chili, bacon and green onion.

Gin Mill

124 East Prairie Street
www.ginmilldecatur.com

The Gin Mill has a Mill Horseshoe (one size) for lunch. It is sourdough bread with a chopped filet, rarebit cheese sauce and truffle fries. It also offers a Kentucky Hot Brown.

Locals 101 Bar & Grille

101 South Main Street #100
Facebook

Locals 'shoes include cordon bleu, Philly and poutine. The breakfast 'shoe has the usual breakfast meats, tater tots, and country gravy on a waffle.

Paco's Sol Bistro

237 North Main Street
www.solbistro.com

Paco's has a one-size chicken, meatloaf or ham plus turkey 'shoe. Hamburger, ham, turkey, BBQ chicken or chipotle hamburger or chicken 'shoes come in two sizes. These are on Texas toast with French fries, topped with homemade queso dip, bacon bits, fried onion straws and chives.

Pop's Place

4335 West Main Street
Facebook

Pop's offers the usual horse and pony 'shoes.

The Wharf

201 First Drive West
www.thewarfdecatur.com

The Wharf has a one-size horseshoe with cheddar and Monterey cheese sauce. It might have a choice of fries.

DELAVAN, ILLINOIS

Farmhouse

120 East Fifth Street
Facebook

The Farmhouse has a one-size horseshoe with white or yellow cheese sauce.

DIVERNON, ILLINOIS

Patsy's on the Square

100 West Kenney Street
www.patsysonthesquare.net

Patsy's offers a breakfast 'shoe with gravy or cheese sauce. Reviews on Yelp say the cheese sauce on the horseshoe is "very good" and "fantastic." The horseshoe does not show up on the online menu. Divernon is a Route 66 town.

Toni's Café

379 West Route104
Facebook

A chiliburger 'shoe is pictured on the café's Facebook page.

EASTON, ILLINOIS

TT's

210 East Main Street
Facebook

TT's has a pony 'shoe pictured on Facebook.

EAST PEORIA/PEORIA, ILLINOIS

Burger Barge

1401 North Main Street and 123 Meadow Avenue, East Peoria,
714 West Lake Avenue, Peoria
www.burgerbargeinc.com

With three locations in East Peoria and Peoria, Burger Barge has something called "Anchor Pies." The description and picture resemble a horseshoe. "The Anchor" is a burger and fries with bacon, mozzarella cheese, grilled onion, mushrooms, cheese sauce and something called "dock sauce." A "Breakfast Anchor" includes a fried egg. There is also a "Rusty Anchor" with "our meat sauce" and a Pizza Anchor with "our Lucy meat." The "Sunday Dinner Anchor," which has the burger and fries topped with mashed potatoes, rib eye and roast beef gravy, is probably out of the realm of horseshoes.

EDINBURG, ILLINOIS

(The) Burg

105 West Washington Street
Facebook

The Burg has horse or pony breakfast 'shoes with a choice of potatoes, breakfast meats and gravy or cheese sauce. The "It's a Shoe In!" comes in a pony, horseshoe or "trifecta," which is larger, and the usual meat choices.

EDWARDSVILLE, ILLINOIS

Bull and Bear Grill and Bar

1071 IL-157
www.bullandbeargrillandbar.com

Bull and Bear, located on Historic Route 66, offers a one-sized horseshoe of deli turkey, roast beef or hamburger, seasoned fries and chili.

Sgt. Peppers

218 North Main Street
www.sgtpepperscafe.net

See the Springfield Sgt. Peppers information. The menu says "Home of the Horseshoe" and offers the same choices as Springfield, except for the cod.

Stagger Inn...Again

104 East Vandalia Street
www.staggerinnagain.com

Billed as "Edwardsville's oldest continuously operating drinking establishment," the Stagger Inn offers a one-size horseshoe as a burger on French bread with pepper jack cheese sauce.

EFFINGHAM, ILLINOIS

Gabby Goat American Pub & Grill

303 East Fayette Street
www.gabbygoat.com

Gabby Goat offers a horse or pony 'shoe with yellow or white queso and the usual meat choices.

Niemerg's Restaurant

1410 West Fayette Avenue
www.niemergssteakhouse.com

Open since 1978, Niemerg's offers the usual horse and pony 'shoe choices.

ELKHART, ILLINOIS

Gina's Talk of the Town

115 Governor Oglesby Street
Facebook

Other people were associated with "Talk of the Town" before Gina. It has horse and pony 'shoes with the usual choices a few blocks from Historic Route 66.

EL PASO, ILLINOIS

Topsy's Bar & Grill

23 West Front Street
Facebook

Topsy's has a one-size hamburger horseshoe, which is a "Monday night special."

FAIRVIEW HEIGHTS, ILLINOIS

Lotawata Creek Southern Grill

311 Salem Place
www.lotawata.com

Lotawata Creek has two one-size horseshoe choices. The cheesesteak is thin strips of sirloin grilled with sliced onions, and the chili cheeseburger has a burger and chili. Both have American cheese sauce on top of the meat,

then fries, then "homemade horseshoe cheese sauce." The cheesesteak is topped with tomato and green onions, while the chili cheeseburger has more cheese on top of the cheese sauce.

FARMER CITY, ILLINOIS

Imo's

912 East Clinton Avenue
Facebook

Open since 2000, Imo's has the usual horseshoe choices.

FARMERSVILLE, ILLINOIS

Caddyshack Sports Bar & Grill

505 Main Street
Facebook

A picture of a horseshoe is on Caddyshack's Facebook page. It offers the usual choices plus a supreme, rib eye and "Chad's Loose Meat." The bar and grill is near Historic Route 66.

GALESBURG, ILLINOIS

Sully's Pub

1075 North Henderson Street
Facebook

Sully's Horseshoe is a one size with either sliced ham and turkey or hamburger and "hot" cheese sauce.

GARDNER, ILLINOIS

Vino's Bar & Grill

120 Depot Street
Facebook

Located near Historic Route 66 in the small town of Gardner, Vino's offers a one-size horseshoe.

GIRARD, ILLINOIS

Ron's Red Bird

112 West Center Street
Facebook

No menu is posted, but there is an online photo of a person eating a horseshoe.

Whirl a Whip

309 South Third Street
Facebook

Opened in 1957, Whirl a Whip closed and reopened in 2013. This is a Route 66 landmark. Regular horse or pony 'shoes include the usual choices with "our award winning homemade white cheese sauce." It also has specialty 'shoes of Cajun with a choice of meat or Mexican with a flour tortilla instead of bread, choice of meat and salsa.

GODFREY, ILLINOIS

Round Table

5407 Godfrey Road
Facebook

Although a menu wasn't posted on Facebook, reviewers indicate they have breakfast 'shoes and horse or pony 'shoes that they liked.

GREENFIELD, ILLINOIS

The Bent Fork

418 Main Street
Facebook

The Bent Fork has a breakfast horse or pony 'shoe along with the usual meat choices for the regular horse or pony 'shoes.

GREENVILLE, ILLINOIS

Kahunas Burgers

104 West Harris Avenue
www.kahunasburgers.com

Kahunas has hamburger horse or pony 'shoes with nacho or white cheese sauce.

GRIGGSVILLE, ILLINOIS

Teddy's Bar & Grill

110 West Quincy Street
Facebook

Teddy's has a pony 'shoe with hamburger or chicken strips.

HAMEL, ILLINOIS

Weezy's (66)

108 South Old US Route 66
Facebook

Weezy's is a destination on Historic Route 66 and has the usual horse or pony 'shoes.

HAVANA, ILLINOIS

Babes on Plum

118 North Plum Street
Facebook

The Babes 'shoe has a "signature" yellow or white cheese sauce with hamburger, grilled or breaded tenderloin, Philly cheesesteak, chicken strips or a tater tot 'shoe. Toppings include bacon, tomato, green onion and sour cream. They have a half or full 'shoe.

Grandpa's

117 West Main Street
Facebook

Grandpa's has one-size horseshoes with the usual choices, including veggies. One person on a horseshoe page thinks Grandpa's 'shoes are the "best."

Town House

116 West Market Street
Facebook

Town House has both horse and pony 'shoes with "signature skinny fries and our own cheese sauce."

Wooden Nickel Saloon

15755 State Road 78

There does not appear to be a website or Facebook page for the Wooden Nickel. At least two people on the horseshoe page said the Wooden Nickel had the "best" 'shoes.

HILLSBORO, ILLINOIS

Broad Street Bar & Grill

202 South Broad Street
www.broadstreetgrill.wixsite.com

Broad Street has a pony 'shoe on the menu but doesn't specify meat choices.

Hills Garden Family Restaurant

212 South Main Street
Facebook

Hills Garden has a breakfast horseshoe with the usual meat and potato choices. The pony 'shoe does not specify meat choices.

Mulligans Lakeside Restaurant

1 Country Club Road
Facebook

Mulligans has the usual horse and pony 'shoe choices.

ILLIOPOLIS, ILLINOIS

Bunker's Bar and Mess Hall Restaurant

220 Old Route 36
Facebook

Reviews of the breakfast 'shoe indicated they are good. In August 2017, someone said the cheese sauce on the horseshoe "was amazing." A menu shows Bunker's Bar has horse or pony 'shoes with various chicken choices, hamburger, bacon, ham, pork tenderloin, Philly cheesesteak and a Reuben.

Uncle Monkeys

100 Dye Road
Facebook

Uncle Monkeys has the usual horse and pony 'shoes.

IPAVA, ILLINOIS

Pottsie's Roadhouse

70 West Main Street
Facebook

Pottsie's has the usual horseshoe choices.

JACKSONVILLE, ILLINOIS

Handlebar Pizza and Pub

304 South Main Street
www.thehandlebarpub.com

The Handlebar offers one-size horseshoes.

Kottage Kafe

1850 South Main Street
Facebook

Kottage Kafe offers a breakfast horse or pony 'shoe with a choice of breakfast meats, hash browns or American fries and sausage gravy. It also has the usual horse/pony 'shoes.

Mulligan's

7 West Central Park Plaza
Facebook

Mulligan's has horse and pony 'shoes with the usual meat choices. It also has corned beef or chili 'shoes. The white cheese sauce is homemade.

Rudi's Grill

1913 West Morton Avenue
Facebook

Rudi's offers seventeen different meat choices plus an offer to make a horseshoe from anything on the menu. Horse or pony 'shoe choices include chicken nuggets as well as a variety of strips, taco meat, clam or catfish strips and country fried steak. Tater tots, hash browns or waffle fries can be substituted for French fries.

Twyford's BBQ and Catering

2562 Twyford Road and foodtruck
www.twyfordsbbq.com

Twyford's uses smoked meats (brisket, pork, chicken) in its horseshoes, which have "special cheese sauce."

JERSEYVILLE, ILLINOIS

Fran & Marilyn's

113 South State Street
Facebook

Although Fran & Marilyn's doesn't have a menu posted, a photo of a horseshoe is on its Facebook page, and a person said the horseshoes are "absolutely delicious."

KILBOURNE, ILLINOIS

Mad Jack's Bar & Grill

102 North First Street
Facebook

Mad Jack's has the usual horseshoes.

LATHAM, ILLINOIS

Korn Krib

2371 North Route 121
Facebook

Korn Krib offers the usual meat choices in its Krib 'Shoe, which also comes in a pony.

LEWISTOWN, ILLINOIS

2 Cousins on Main

260 North Main Street
Facebook

2 Cousins has horse and pony 'shoes with the usual choices. Two people on a Facebook horseshoe site said the restaurant had the best 'shoes.

LINCOLN, ILLINOIS

Blue Dog Inn

111 South Sangamon Street
Facebook

Blue Dog Inn has been open since about 1979 and offers several horseshoe choices (hamburger, turkey, corned beef, ham, roast beef, breaded or unbreaded shrimp, chicken or bacon) served on white bread, with the usual French fries and a homemade cheese sauce. There also is a pony 'shoe.

Idle Hour Inn

404 Broadway
Facebook

Idle Hour offers the usual horseshoe.

Imo's Café

616 Woodlawn Road
https://imos-café.business.site

The owner said the horseshoe is in "high demand" at this newly opened restaurant.

Logan Lanes Sports Bar & Grill

1700 Fifth Street
www.loganlanes.com

Logan Lanes has a horseshoe on the menu along with bowling.

LITCHFIELD, ILLINOIS

(The) Ariston Café

413 North Old Route 66
www.ariston-cafe.com

The Ariston Café might be the oldest café on Historic Route 66. Opened in Carlinville on Route 4 (which later became Route 66) in 1924, it moved to Litchfield in 1935. The café is listed in the Route 66 Hall of Fame and the National Register of Historic Places. It has a one-size horseshoe of turkey, ham, bacon and tomato, hamburger, buffalo chicken or deep-fried bacon "smothered in hot, golden cheese sauce."

Jubelts

303 North Old Route 66
www.jubelts.com

Jubelts started as a bakery in 1922 in Mount Olive, Illinois. It moved to Litchfield in 1952 and began serving sandwiches in the 1970s. Jubelts moved to its current location on Historic Route 66 in 1982. It has the usual meat choices in the pony/horse 'shoes, including rib eye. It offers a "supershoe," a hamburger 'shoe with bacon and onion rings on the top. It also has a kids' 'shoe with shoestring fries. The regular 'shoes have steak fries. Breakfast 'shoes have the usual meat choices on biscuits rather than bread. They are topped with half sausage gravy, half cheese sauce and hash browns.

Stacey's Route 66 Café

318 South Old Route 66
Facebook

Stacey's has the usual horse and pony 'shoe choices but will also do special requests. It has white queso and cheddar cheese sauce choices. The breakfast 'shoe has a biscuit, choice of meat, potatoes and two eggs.

LIVINGSTON, ILLINOIS

Twistee Treat Diner

908 Veterans Memorial Drive
Facebook

This '50s-style diner near Historic Route 66 has both horse and pony 'shoes.

LONDON MILLS, ILLINOIS

Spoonies Bar & Grill

103 North Third Street
Facebook

Spoonies has the usual horseshoe choices in one size. A person on Facebook said they were "awesome." Somebody posted about a breakfast 'shoe, but it wasn't on the restaurant's Facebook page.

Route 66 Café

318 South Old Route 66
Facebook

Route 66 offers a breakfast 'shoe as well as regular pony/horse 'shoes. The usual meat choices are enhanced by a barbecue choice and cheese sauce is either cheddar or white queso.

MACKINAW, ILLINOIS

River Road House

30573 State Road 9
Facebook

They have horse and pony 'shoes listed on the menu.

MACOMB, ILLINOIS

Chubby's

2 West Side Square
Facebook

Chubby's horse and pony 'shoes can be enhanced with grilled mushrooms, onions, jalapeños, hot giardiniera, tomato, bacon or chili. Meat choices include hamburger, buffalo, turkey and meatloaf. It also has a "Chubby's donkey" that patrons say is the "best 'shoe around!" It has tater tots and a fried egg. (Chubby's also has a "hot brown burger.")

Jackson Street Pub

835 West Jackson Street
Facebook

Jackson Street Pub offers the usual meat choices plus garden or taco burgers. It also has a hot dog horseshoe. The pub uses lattice fries, and its Facebook page has a photo of a hamburger 'shoe. Items that can be added include chili and jalapeno peppers.

Rocky's Bar & Grill

1420 West Jackson Street
Facebook

A menu isn't posted, but TripAdvisor indicates Rocky's has horse and pony 'shoes. It is also mentioned on horseshoe pages.

MAHOMET, ILLINOIS

JT Walker's

401 East Maine Street
www.jtwalkers.com

JT's Horseshoes are listed for lunch and dinner with sourdough bread and queso. The meat choices are not listed, and there is just one size.

MARION, ILLINOIS/MURPHYSBORO, ILLINOIS

17th Street BBQ

2700 Seventeenth Street / 32 North Seventeenth Street
www.17bbq.com

"It's All About the Shoes: Our Riff on Springfield Illinois' Famous Horseshoe" is a one-size pork shoulder patty with the usual fries and cheese sauce.

MASON CITY, ILLINOIS

Smokey's Bar & Grill

50 North Tonica Street
Facebook

Although a menu isn't posted on Facebook, pony 'shoes show up as "specials" and are mentioned in horseshoe posts.

MATTOON, ILLINOIS

Hubbart's

1626 Broadway Avenue
www.hubbartsdowntowndiner.wordpress.com

Opened in 2017, Hubbart's has one size of the usual choices at the "Horsey 'shoe factory." It uses Monterey Jack cheese sauce.

Pagliacci's

319 North Logan Street
Facebook

Pagliacci's has the usual horse and pony 'shoe choices.

Spanky's

1920 Oak Avenue
Facebook

Spanky's has ham, chili and "horse" 'shoes.

Stadium Grill

102 Dettro Drive
www.mattoonstadiumgrill.com

Stadium Grill offers a burger, chicken or corned beef 'shoe with queso and mixed cheese.

MECHANICSBURG, ILLINOIS

Buckhart Tavern

11000 Buckhart Road
Facebook

Although the address is Mechanicsburg, the tavern is technically in the little town of Buckhart. It has the usual horseshoe choices with just one size.

MIDDLETOWN, ILLINOIS

Stagecoach Bar and Grill

104 South Madison Street
Facebook

The Stagecoach features both horse and pony 'shoes on its Facebook page.

MORRIS, ILLINOIS

Honest Abe's Tap and Grill

3583 IL 47
www.honestabestapandgrill.com

Honest Abe's has a large section of the menu devoted to "The Springfield 'Shoe." Information on the menu mentions the importance of Springfield to Lincoln's political career and the creation of the horseshoe. It offers the usual meat choices in a pony or horse 'shoe with the addition of garlic pork, and the "rich and creamy homemade cheese sauce" comes in regular and spicy. The 'shoe is garnished with chopped onions.

MORTON, ILLINOIS

Schooners

630 West Jackson Street
Facebook

Schooners has a one-size horseshoe.

MOUNT OLIVE, ILLINOIS

Tilleys Tavern

303 East Main Street
Facebook

Tilleys has a one-size 'shoe of beef or chicken. Mount Olive is on Historic Route 66.

MOUNT PULASKI, ILLINOIS

Farmers Family Restaurant

304 East McDonald Street
Facebook

Although a menu isn't posted, specials and photos indicate that Farmers has horse and pony 'shoes, including a brisket pony special. A reviewer said the breakfast 'shoe was "fantastic."

The Old Brickyard Grill & Pub

105 South Lafayette Street
www.theoldbrickyardgrillandpub.com

The Old Brickyard has "homemade cheese sauce" on eight meat choices for the horse or pony 'shoes.

MOUNT STERLING, ILLINOIS

Tastee Treet

423 East Main Street
Facebook

Tastee Treet has horse and pony 'shoes.

MOUNT VERNON, ILLINOIS

Frosty Mug Bar & Grill

1113 Salem Road
www.frostymugbar&grill.com

The Frosty Mug has a one-size 'shoe with cheddar cheese sauce. Bacon can be added to top.

NAPLES, ILLINOIS

Evandys Boatel

100 Bob Michael Street
www.m.evandysboatel.com

Evandys Boatel has horse or pony 'shoes for lunch with the usual meat choices, including bacon. All are served with "signature Evandy's cheese sauce."

NEW BERLIN, ILLINOIS

Double Crown Restaurant

Waverly Road at Old Route 54
Facebook

Double Crown has gyro, tenderloin and chicken horse or pony 'shoes with white cheese sauce, according to reviews. A menu isn't posted, so there could be other choices.

NOKOMIS, ILLINOIS

Depot Pub

590 North Fifth Street, Coalton, which is right next to Nokomis
Facebook

The menu says "Sandwiches, Shoes & Baskets." It has hamburger, tenderloin, ham, chicken, pot roast or fish pony or horse 'shoes.

NORMAL, ILLINOIS

Merry Ann's Diner

www.merryannsdiner.com

See Champaign-Urbana Merry Ann's Diner

OAKFORD, ILLINOIS

J&D's Family Restaurant

103 West Center Street
Facebook

J&D's has horse or pony 'shoes with the usual meat choices.

O'FALLON, ILLINOIS

Hop House Southern Eatery

1214 Central Park Drive
www.hheatery.com

Hop House has a one-size 'shoe of hamburger, brisket or pulled pork. The fries are "twisted," and the cheese sauce is "house made."

OGLESBY, ILLINOIS

Delaney's Family Restaurant

100 North Lewis Avenue
www.delanysbuffet.com

Roast beef, hamburger or deep-fried chicken breast is served on Texas toast points. French or waffle fries are covered with cheddar cheese sauce and garnished with diced tomato and bacon bits.

MJs Bar & Grill

139 East Walnut Street
Mjspub.wixsite.com

The one-size hamburger 'shoe has cheddar cheese sauce and a touch of bacon.

OLNEY, ILLINOIS

Chilly Willey's

416 East Main Street
Facebook

Chilly Willey's horseshoes (one size) are listed as "new" items.

OTTAWA, ILLINOIS

A'Lure Aquarium Bar & Restaurant

2132–215 West Madison Street
www.ottawaalure.wixsite.com

Opened by the owners of MJ's Pub in Oglesgy (which also has horseshoes), A'Lure carries a hamburger horseshoe, available for lunch. It has "sharp cheddar sauce" and real bacon.

New Chalet Restaurant

514 State Street
www.thenewchalet.com

New Chalet's one-size hamburger horseshoe has diced bacon and "our cheese sauce."

PALMYRA, ILLINOIS

Old No. 7 Saloon

103 East State Street
Facebook

Old No. 7 Saloon's horse or pony 'shoe has the usual meat choices with Monterey Jack cheese sauce.

PANA, ILLINOIS

Cindy's Longhorn Lounge Bar & Grill

2517 IL Route 16
www.cindysck.com

Cindy's has a full- or half-size hamburger 'shoe with CCK "signature cheese sauce." The hamburger is made from natural Texas longhorn beef. When the restaurant was known as Cindy's Country Kitchen, it had a "Horseshoe Challenge" with pictures and T-shirts. It appears that this changed when the name changed in 2017.

PARIS, ILLINOIS

Main Street Café

226 North Main Street
Facebook

Main Street Café has two choices of 'shoe with "smooth cheddar cheese sauce."

Tuscany Steak and Pasta House

1218 North Main Street
Facebook

Tuscany Steak and Pasta House has the usual hamburger horseshoe.

PEKIN, ILLINOIS

Maquet's Rail House

221 Court Street
Facebook

Maquet's Rail House offers the usual meat choices in a horse or pony 'shoe with Monterey Jack cheese sauce.

PEORIA, ILLINOIS

Childers Eatery

3312 North University Street/5805 North Humboldt Ave No. 5
www.childerseatery.com

Childers Eatery's one-size 'shoe is made of brioche, an Angus beef burger, applewood bacon, jalapeño tater tots, smoked gouda cheese sauce and minced chives.

Hungry Moose

4808 West Farmington Road
Facebook

The Hungry Moose's "Moose 'shoe" has either a Mooseburger patty or tenderloin.

Industry Brewing

8012 North Hale Avenue
Facebook

Industry Brewing has an interesting twist on the bread base. It appears the kitchen uses "fried panko encrusted Mac & Cheese," since the rest of the horseshoe is "crinkle cut fries, 2 quarter pound Angus beef patties, Industry Pale Ale beer cheese sauce and BBQ sauce." There is just the one size and meat choice. One person on a horseshoe page thinks this 'shoe is the "best."

Kenny's Westside Pub

112 Southwest Jefferson Avenue
www.kennyswestside.com

Kenny's has hamburger or chicken horseshoes or "tot 'shoes." The tot 'shoes are supposed to be very good according to a horseshoe page post.

PETERSBURG, ILLINOIS

Gillmore's Restaurant

501 South Sixth Street
Facebook

The Gillmore family has had restaurants in Petersburg since the 1950s. This restaurant opened in 1995, and the café prides itself on using locally grown food. It also makes its own own hamburger each day. Horse and pony 'shoes are the usual choices, but Gillmore's will also do special orders like vegetables instead of meat.

PIERRON, ILLINOIS

Wooden Tie Café

206 State Road 143
Facebook, www.woodentiecafe.com

The café opened in 2017 in a rehabilitated 1903 house, and the owners said horseshoes had to be on the menu since it's called the Wooden Tie. The owner made a wooden tie, and people are pictured wearing it. The café offers the standard horseshoe with chili on the top and uses locally sourced food. A reviewer said he'd had his first horseshoe there and it was "fantastic."

PITTSFIELD, ILLINOIS

Dome on Madison

109 North Madison Street
www.domeonmadison.com

Dome on Madison has a horse or pony 'shoe made with a "dome burger."

PLEASANT HILL, ILLINOIS

Pony Express at the Stagecoach Inn

204 South Bay Street
Facebook

Pony Express has horse and pony 'shoes with the usual meat choices.

PLEASANT PLAINS, ILLINOIS

Grainery Bar and Grill

210 IL125
Facebook

Grainery has a photo of a "Hog Holler Horseshoe" on Facebook. It includes chicken strips and hamburger and is topped with bacon. It is described as "awesome."

PONTIAC, ILLINOIS

DeLongs' Casual Dining and Spirits

201 North Mill Street
www.delongscasualdining.com

Located near Historic Route 66, DeLongs' has the usual one-size horseshoe.

Edingers Filling Station

423 West Madison
www.edingersfillingstation.com

Edingers offers the usual horseshoes as one of "the classics."

QUINCY, ILLINOIS

(The) Abbey

1736 Spring Street
www.theabbeyquincy.com

The Abbey has a one-size, quarter-pound flame-broiled burger on garlic toast with "our own secret cheese sauce."

Café J

1400 North 30ᵗʰ Street #1
Facebook

Café J's BBQ pork pony has "Almost Famous BBQ pork" and cheddar cheese sauce.

Elder's Restaurant

1800 State Street
www.eldersrestaurant.com

Elder's has a one-size "Elders Horseshoe."

Mr. Bill's Bar & Grill

538 South Twelfth Street
Facebook

A large section of the menu is devoted to 'shoes. The horse and pony 'shoe choices are hamburger, ham or roast beef. There also is a chicken 'shoe, BBQ pork 'shoe, BBQ beef 'shoe or tenderloin 'shoe. These are all "smothered in warm cheddar cheese sauce." The Ultimate 'shoe (burger with tomato, jalapeño and bacon bits) and the Philly 'shoe (Philly steak, grilled onions and peppers) have white queso sauce.

O'Griff's Irish Pub, Grill and Brew House

415 Hampshire Street
Facebook

O'Griff's pony 'shoe choices include burgers, shredded roast beef or BBQ pork with jalapeno cheese sauce.

RANTOUL, ILLINOIS

Public House

108 North Garrard Street
Facebook

Public House offers a one-size 'shoe of cod, tenderloin or hamburger.

RED BUD, ILLINOIS

The Shoe

1017 South Main Street
Facebook

The "famous" 'shoes come in horse, pony and colt sizes with locally sourced meat.

ROCHESTER, ILLINOIS

The Alibi

320 East Main Street
www.the-alibi.com

The Alibi's one-size horseshoe is an Angus beef patty and fries with house cheese sauce.

Lighthouse Family Restaurant

201 South Walnut Street
www.lighthousefamilyrestaurantrochester.com

The Lighthouse offers horse, pony and colt 'shoes. The colt is even smaller than a pony. Choices are the usual: hamburger, ham, fried chicken strips, grilled chicken, Italian beef or breaded pork tenderloin. They also have a breakfast 'shoe with hash browns.

Public House 29

312 Sattley Street
www.pubhouse29.com

Public House 29 has "regional favorites," including Kentucky hot browns and the "Slinger" as well as horseshoes (one size). Along with the usual choices, it has pork burger or bologna with Public House 29 white cheese sauce and a "Public House" sandwich, which is "house smoked and slow cooked pork belly on Texas toast with French fries, white cheese sauce and crumbled house made bacon."

RUSHVILLE, ILLINOIS

Deb & Di's

US 67
Facebook

Deb & Di's doesn't have a menu posted, but it does have a photo of a pulled pork BBQ 'shoe on Facebook.

Sultans

705½ West Clinton Street
Facebook

Sultans has a breakfast horseshoe with gravy or cheese sauce, a choice of ham, sausage or bacon with eggs and potatoes over toast. The one-size

horseshoe sandwich has the usual meat choices with "secret" cheese sauce. At least one person thought Sultans' 'shoe was the best on a horseshoe page.

SAINT AUGUSTINE, ILLINOIS

Twisted Sisters

202 State Road 116
Facebook

Twisted Sisters offers a one-size horseshoe.

SAVOY, ILLINOIS

Smoky's House

1333 Savoy Plaza Lane
www.smokyshousesavoy.com

Smoky's House offers a one size, one type of horseshoe.

SHEFFIELD, ILLINOIS

Reds Bar

127 East Railroad Street
Facebook

Reds Bar has the usual meat choices on a one-size 'shoe with nacho cheese sauce. At least one person on a horseshoe page thought this 'shoe was the "best."

SHELBYVILLE, ILLINOIS

Druby's

520 West Main Street
www.drubys.com

Opened in 1992, Druby's has pony and horse 'shoes and Clydesdales. These are not described in more detail, but a photo of a Clydesdale from 2014 is on Facebook.

SHERIDAN, ILLINOIS

Cadillac Grill

135 West Si Johnson Ave
Facebook

Cadillac Grill has a one-size horseshoe with the usual meat choices, nacho cheese (sauce), green onions and tomato.

SHERMAN, ILLINOIS

Fairlane Diner

300 Crossing Drive
www.fairlanediner.org

Fairlane Diner has the usual horse or pony 'shoes along with a "Coney pony," which includes a grilled hot dog and chili dog topping. The diner décor highlights its closeness to Historic Route 66.

Fire & Ale

135 Illini Drive
www.fireandale.net

Fire & Ale has a 'shoe with the following choices: chicken breast, buffalo chicken, pulled pork, turkey, ham, pork tenderloin or applewood bacon.

SHIPMAN, ILLINOIS

16 Bar & Grill

264 East Railroad Street
Facebook

Although a menu isn't posted, 16 Bar & Grill has a BBQ horseshoe special, and people on Facebook pages have said it has 'shoes.

STAUNTON, ILLINOIS

Decamp Junction

8767 State Road 4
Facebook

Located on Historic Route 66, Decamp Junction has the usual pony 'shoe choices.

R&B's Restaurant

802 South Hackman Street
www.randbsrestaurant.com

Horse or pony 'shoes are listed as a specialty on the menu. R&B's has the usual meat choices with cheddar or "homemade" beer cheese sauce. Hackman Street in Staunton is part of historic Route 66.

STREATOR, ILLINOIS

Chix

310 North Park Street
www.eatatchix.com

Chix's one-size horseshoe is on garlic toast with cheese sauce and bacon pieces.

SULLIVAN, ILLINOIS

Hole in the Wall BBQ

16 North Washington Street
Facebook

Hole in the Wall's horse or pony 'shoe comes with BBQ sauce.

Skeeters

1158 State Highway 32
Facebook

Skeeters has a one-size horseshoe.

TAYLORVILLE, ILLINOIS

Bill's Toasty Shop

111 North Main Street
Facebook

Bill's has "been around since the 1930s." Open 24/7 with ten stools and two booths, it has the usual meat choices (the burgers are supposed to be

A horseshoe at historic Bill's Toasty Shop, Taylorville, Illinois. *Carolyn Harmon.*

the best in town) with cheddar cheese sauce. One person rated the 'shoe as the "best" on a horseshoe page.

Burton's Tap

110 West Taylorville Road
Facebook

Burton's Tap has the usual 'shoe choices.

Krieger's

105 West Bidwell Street
Facebook

The horseshoe (one size) is listed as "one of our classics." The French fries are seasoned, and the sauce is cheddar cheese.

Spring Garden

1220 West Springfield Road
Facebook

Spring Garden offers one-size horseshoes with the usual meat choices and white or yellow cheese sauce.

THAYER, ILLINOIS

Mick & Mary's

310 East Ebony Street
Facebook

Although Mick & Mary's had a fire in September 2017, it reopened in November. Along with the usual horseshoe choices, it has gizzard or liver 'shoes. A review said the pony 'shoe cheese sauce was excellent. Josh Snodgress is the current owner of the restaurant, which was once Maggie's. Maggie and her husband, bootlegger Dominick (Mick) Enrietta, opened the restaurant in 1926. The original building burned down in 1992 and was replaced with a new building, which had a fire in 2009 as well. Thayer is on Historic Route 66

Pudock's Hideout Bar & Grill

207 East Main Street
Facebook

Located near Historic Route 66, Pudock's has "Route 66 Horseshoes" with the usual meat choices.

TREMONT, ILLINOIS

Perdue's Grill

201 South Sampson Street
www.perduesgrilltremont.com

Perdue's menu says, "Springfield claims to have invented the horseshoe but we have perfected it!" It has one-size horseshoes with turkey burger, chili cheese hot dog or rib eye along with the usual choices. The Four Horseman Challenge is: "Eat a hamburger, hot dog, breaded pork and ham horseshoe in one hour or less and receive a T-shirt and a $20 gift card to use on your next visit! Will your name end up on our wall of fame or our wall of shame?! $30.99 (dine-in only and absolutely no sharing)." At least one person thinks their horseshoes are the "best" according to a post on a horseshoe page.

VANDALIA, ILLINOIS

Chuckwagon Café

704 Janette Drive
Facebook

The café has a hamburger horse or pony 'shoe.

VIRDEN, ILLINOIS

Jo's Place

217 East Jackson Street
Facebook

Located near the town square, Jo's offers the usual meat choices on its horseshoes. The breakfast pony comes with hash browns or cottage fries and sausage gravy.

Showtime Lanes

1515 North Springfield Street
www.showtimelanes.com

Opening about 1994, the restaurant is part of a bowling alley complex. It is located on Route 4, which was Historic Route 66. It offers a breakfast pony with hash browns or American fries, the usual breakfast meat choices and cheese sauce or country gravy. Although the regular horse and pony 'shoes offer the typical meats, other items can be substituted like walleye. They have thinner shoestring or thicker crinkle cut French fries and the choice of cheddar or white cheese sauce. Chili can be added to top as well as chopped onions, tomatoes and peppers if requested.

VIRGINIA, ILLINOIS

Depot Diner

351 North Main Street
www.visitthedepot.com

This diner, located in an historic train depot, explains the history of the horseshoe on its menu and website. Along with the usual meat choices, it has roast beef, bacon and an assortment of "Cass County Specialties." These include BBQ, Philly cheesesteak, buffalo or honey citrus chicken strips, taco, corned beef, Reuben and breaded catfish. It offers American, waffle or cottage fries along with regular French fries. You can "derail your horseshoe" with grilled onions, peppers, mushrooms and tomatoes and/or bacon. Along with regular and smaller pony 'shoes, the diner has the Clydesdale Challenge. This is "triple the meat, 4 slices of Toast + even more French fries and cheese sauce". If eaten (there doesn't appear to be a time limit), a picture will be placed on the "The Depot's Clydesdale Hall of Fame." It also has "Irish Nachos" on the horseshoe page with the statement: "Not exactly a horseshoe but pretty close." These are "seasoned waffle fries smothered in cheese sauce topped with ground beef, onions, green peppers and tomato. Bacon and/or jalapeno can be added to the top.

WARSAW, ILLINOIS

DJs Bar & Grill

601 Main Street
Facebook

DJs' specialties include a burger horse or pony 'shoe with French fries or the "DJ Mix" with seasoned lattice fries, popcorn chicken, cheddar cheese, ranch and hot sauce.

WASHINGTON, ILLINOIS

Denhart's and Blacksmith Steak House

Historic Washington Square in downtown Washington
www.cornerstoneinnbnb.com

Both restaurants are part of the Cornerstone Inn website. Denhart's is open for breakfast and lunch, while the Blacksmith Steak House is open for dinner. They both serve similar types of one-size horseshoes. Denhart's menu calls it a "Build Your Own Horseshoe" because of the meat choices, including sliced turkey and pulled pork BBQ along with the usual choices. The 'shoes are topped with melted Monterey Jack cheese and shredded cheddar cheese. At least one person thinks their 'shoes are the "best" on a horseshoe page.

WAVERY, ILLINOIS

Verda Mae's

223 North Pearl Street
Facebook

Verda Mae's has twelve choices of 'shoe (one size) plus a "Mexican 'Shoe," which is "ground chuck wrapped in flour tortilla with cheese, fries, green chili sauce, black olives, jalapenos and sour cream." Regular 'shoes can be enhanced with bacon or green chili sauce. Verda Mae's cheese sauce is homemade, and it was on the Horseshoe Quest in 2011.

WEST FRANKFORT, ILLINOIS

Mike's Drive In

1007 West Main Street
Facebook

Mike's Drive In has horse or pony 'shoes with the usual meat choices and "homemade cheese sauce."

WILLIAMSVILLE, ILLINOIS

Huddle House

994 Ann Rutledge Road
www.huddlehouse.com

This is a national chain. Although a horseshoe is not on the menu, the description of the "Southern Smothered Biscuit Platter with Country Sausage or Turkey Sausage" sounds like a breakfast horseshoe: "Fluffy, open-faced biscuit, two sausage patties, crispy hash browns, country sausage gravy and cheddar cheese topped with two scrambled eggs." Huddle House is located near Historic Route 66.

YATES CITY, ILLINOIS

Yates City Deli and Bakery

101 East Main Street
Facebook

Yates City's pony has the usual meat choices. It appears there is just one size.

CHICAGO, ILLINOIS

Bridgehouse Tavern

321 North Clark Street
www.bridgehousetavern.com

Although the website has a photo posted of a person who finished a BHT 'shoe in 2013, horseshoes don't currently appear on the menu.

6 Degrees

1935 North Damen (Bucktown)
www.6degreesbucktown.com

Owned by former Springfield resident Ann Keefner, 6 Degrees has received media attention, including several Chicago websites. It is featured in YouTube videos from an NPR visit for *Wait, Wait Don't Tell Me* in 2010 and "Chicago's Best Regional Bites" in 2012. A February 2018 video also highlights the horseshoes. 6 Degrees offers the "Infamous Horse Shoe Sandwich," which Keefner notes "originated in Springfield, IL." The horseshoe comes with two meats, while the pony has one. Healthier veggie burger and vegetarian options are available with "signature Welsh rarebit cheese sauce" topped with fries. A video makes clear the owner believes the fries should go on after the cheese sauce (like the original). There also is an "Infamous Breakfast Horse Shoe" for brunch. Two breakfast meats, eggs and "specialty cheese sauce" are completed with hash browns.

Horse Thief Hollow Craft Brewery

10426 South Western Avenue
www.horsethiefbrewing.com

The one-size hamburger "The Shoe: A Springfield Tradition" is listed as an entrée. A person named Jim tried the horseshoe and commented on www.sandwichtribunal.com, including a discussion of whether the horseshoe is really a sandwich.

FOREST PARK, ILLINOIS (NEAR CHICAGO)

Exit Strategy Brewing Company

7700 Madison Street
www.exitstrategybrewing.com

Their one-size buffalo horseshoe is made of fried chicken breast, buffalo sauce and the usual fries, cheese sauce and thick-cut toast.

ST. LOUIS, MISSOURI AREA

Some Illinois cities such as Collinsville, Edwardsville and Belleville are in the St. Louis area but are listed already. One chain covers both Illinois and Missouri.

Big Daddy's (www.bigdaddystl.com) has four locations, including Belleville (313 East Main Street) and Edwardsville (132 North Main Street) and two St. Louis locations, Soulard (1000 Sidney Street) and Lacledes Landing (118 Morgan Street).

It has a one-size "Big Daddy's Horseshoe" with a choice of meat and "warm Nacho sauce."

ELDON, MISSOURI

Silver Dollar

20 Acorn Drive

The Silver Dollar is near the Ozarks. Based on reviews, it appears that the restaurant has horseshoes. There is no menu posted.

HANNIBAL, MISSOURI

Logues Restaurant

121 Huckleberry Drive
www.loguerestaurant.com

Opened in 1986, Logues has one-size "Horseshoe Burger Skillet" or "Chicken Shoe Filet Skillet."

Mark Twain Dinette

400 North Third Street
www.marktwaindinette.com

Opened in 1942, Mark Twain Dinette became a Maid-Rite franchise in 1967. It has a "Dinette Horseshoe" with onion rings, cheese and chili-ranch. The Horseshoe Tenderloin and Horseshoe Maid-Rite all have "house made cheese sauce" on the one-size 'shoes.

VANDALIA, MISSOURI

Goodfellas Bar and Grill

109 West Washington Street
Facebook

Goodfellas has a one-size horseshoe.

BETTENDORF, IOWA

Ross' Restaurant

2297 Falcon Avenue
www.rossrestaurant.com

According to the restaurant website, Harold Ross wanted to start a Maid-Rite after working at one in Iowa. He eventually made Rossburgers after ending his relationship with Maid-Rite. A son-in-law created the "Magic Mountain." This is similar to a Maid-Rite Horseshoe with the usual grilled Texas toast, covered with steamed loose meat and French fries or hash browns. Chopped onions can be placed on top of the cheese sauce (traditional or spicy queso blanco) to make snow or chili for a "Volcano." Other choices include Mexican, Poutine, Barbeque or Cockadoodle Doo Mountains. The Morning Mountain is a breakfast horseshoe with Texas toast, hash browns, a sausage patty, a local scrambled egg, the

choice of cheese sauce or sausage gravy (or half cheese sauce and half sausage gravy). The Tipsy Rooster uses a German-style pretzel topped with chicken tenders, French fries, house made beer cheese sauce, chopped green onions and bacon. Children can join the Junior Mountain Climbers Club with a Junior Magic Mountain. The Magic Mountain has been featured on *Good Morning America*, *The Rachel Maddow Show* and in national newspapers. Celebrities like Bette Midler and President Obama have tried Magic Mountains, according to an article in the *Des Moines Register*.

BURLINGTON, IOWA

Buffalo Tavern

2016 South Main Street
www.thebuffalotavern.ninja

Tenderloin horseshoes are served over an open-face toasted bun, topped with French fries, drizzled with Monterey Jack cheese sauce, peppers, onions and jalapeños on the top. The buffalo chicken horseshoe is a breaded and fried nine-ounce chicken breast over a toasted bun and smothered with buffalo sauce, Sidewinders*, Monterey Jack cheese, jalapeños and ranch dressing. The sweet BBQ pulled pork horseshoe is a "mountain" of pulled pork over an open-face bun piled high with Monterey Jack–drizzled Sidewinders*, sautéed onions and peppers, jalapeños, French fried onions and sweet BBQ sauce. (Fresh bacon bits can be added.) The "Big Ass Beef Horseshoe" is an eight-ounce burger served over an open-face toasted bun, topped with French fries, drizzled with Monterey Jack cheese sauce and topped with peppers, onions and jalapeños. (*Sidewinders are spiral-cut, beer-battered French fries.)

The Drake Restaurant

106 Washington Street
www.thedrakerestaurant.com

The Drake has a one-size smoked brisket horseshoe.

CLINTON, IOWA

Stouts Irish Pub and Grill

2352 Valley West Court
www.stoutsirishpub.com

Stouts has a one-size "horseshoe burger" on the menu. One person said the pub had the best 'shoes in a Facebook post.

DONNELLSON, IOWA

Charleston Board of Trade

1962 253rd Street
Facebook

A Facebook post said Charleston Board of Trade had the best horseshoes, even though a handwritten menu shows Maid-Rites but no horseshoes.

GRINNELL, IOWA

Montgomery's Sandwich Shop

712 Sixth Avenue
www.montgomerysandwichshop.com

Montgomery's has been open since 1933. It serves a loose meat sandwich that can also be made into a horseshoe like the Maid-Rite Sandwich Shop. "We've taken this Springfield Illinois specialty and made it our own."

KEOKUK, IOWA

Hawkeye Restaurant

105 North Park Drive
www.hawkeyerestaurant.com

Hawkeye's horseshoe burger is a one-size eight-ounce burger on Texas toast loaded with fries, smothered with cheddar cheese and topped with onion rings.

V's Restaurant & Brewhouse

3461 Main Street
Facebook

V's has a one-size vegetarian horseshoe of veggie burger or fried hot pepper cheese balls with fries or mashed potatoes and pepper gravy or queso. The Horseshoe Platter has the usual meat choices with regular fries, sweet potato fries or mashed potatoes and chicken, beef or sausage gravy or queso.

MONTROSE, IOWA

Kinnick on the River

1 Main Street
Facebook

Across the Mississippi River from Nauvoo, Illinois, Kinnick has a one-size hamburger horseshoe or a muleshoe, which includes chili.

EVANSVILLE, INDIANA

Eagle's View Church had horseshoes and "dirty horseshoes" for sale at the West Side Nut Club Fall Festival. The *Evansville Courier Press* provided this description: "'The Horseshoe Sandwich is an open-faced hamburger topped with cheese fries,' said Mark Malek, youth pastor at Eagle's View Church. 'You can make it dirty by adding stuffed pepper soup which is sort of like a chili without beans. Every year we have people getting more of the horseshoe sandwich.'"

TERRE HAUTE, INDIANA

Fifi's Lunch Box

2918 Wabash Avenue
www.fifislunchbox.com

Fifi's offers a "Horseshoe Burger," which is described in the menu as a burger on thick-cut toast, Welsh cheese and topped with loads of fries.

AUSTIN, TEXAS

Hyde Park Bar & Grill

4206 Duval Street
www.hpbng.com

Jason Anderson is the manager and originally from Springfield. Hyde Park has a one-size horseshoe with brisket burger, "Hyde Park fries," onion, tomato and cheese sauce. Hyde Park fries are in buttermilk batter.

ATLANTA, GEORGIA

Black Bear Tavern

1931 Peach Tree Road NE
www.blackbeartavern.net

This tavern advertises it is a location for Chicago sports team fans, so it makes sense it would have a Central Illinois food. The description from the menu for the hamburger horseshoe: "Texas toast, ½ pound Angus beef patty; horseshoe bend of fries, topped with house-made chili and queso."

WOODSTOCK, GEORGIA

Donovan's Irish Cobbler

1025 Rose Creek Drive
www.donovansirishcobbler.com

The website tells the story of the Donovan family, who brought their horseshoe recipe with them when they moved to Atlanta, Georgia, from Springfield. They came up with the cobbler name because an "Irish cobbler" is an Irish potato, a cobbler is a shoemaker and the restaurant has a specialty cobbler dessert. The horseshoe description from the menu: "Texas Toast + Choice of Meat + Fries + Cheese Sauce. Your choice of meat, served over a slice of Texas toast, piled high with fries and topped with 'our unforgettable house-made Donovan's cheese sauce'." "Philly Steak With Mushrooms, Onions and Peppers, Smoked Ham, Corned Beef, Fried Chicken, Grilled Chicken, Fried Buffalo Chicken, Sliced Turkey, Turkey Burger, Sweet & Spicy Chicken, Bangers Or 'Our Favorite'—Hamburger." Donovan's also had a breakfast 'shoe with the usual components that is served for brunch.

GALENA, MARYLAND

Country Kitchen

100 West Cross Street
www.thecoutnrykitchen.net

A story in the Easton, Maryland *Star-Democrat* in 2016 provided a review of the Country Kitchen. Monica Quigg, the co-owner, said that they put horseshoes on the menu because Josh Mikelonis, the other co-owner, was from Springfield, Illinois. Country Kitchen offers hamburger horse or pony 'shoes.

SOUTH HILL, VIRGINIA

Horseshoe Restaurant

311 West Danville Street

The Horseshoe Restaurant has a "Clydesdale" of hamburger, mashed potatoes and grilled onions on a bun covered with gravy and topped with a fried green tomato, pimento, cheese, bacon, lettuce and tomato. Is it a horseshoe?

MARGATE, FLORIDA

Roosters

7370 West Atlantic Boulevard
www.roostersmargate.com

Roosters has a a one-size "The Horseshoe" with melted cheddar cheese or gravy.

TUCSON, ARIZONA

Wings and Rice

5502 East Pima Road #110
www.wingsandrice.com

Wings and Rice has a horse or pony 'shoe on the menu with the usual choices. (Joe and Elizabeth Schweska lived in Tucson in the 1950s and brought the horseshoe with them.)

PARIS, TENNESSEE

A church in Paris, Tennessee, hosted "Horseshoes for Hope" benefits in 2014, 2015 and 2016 for the "Hoof Beats of Hope" program and R.E.A.L. Hope Youth Center. The directors of the R.E.A.L. Hope Youth Center, Linley and Becki White, are from Springfield, Illinois. They said the event was successful but labor intensive. A restaurant in Paris thought about adding horseshoes to its menu, but this hasn't happened yet.

APPENDIX

RECIPES

The Original Horseshoe Recipe

A signed copy of Joe Schweska's recipe for Welsh Rarebit Sauce given to Lorraine Rink in 1938 (thanks to Bob Gonko) and a 1938 newspaper article where Schweska shared his recipe have a few differences from this recipe.

½ pound butter
½ pound flour (2 cups)
1 quart milk
1 tablespoon Worcestershire/Lea & Perrins sauce
1 pound Old English or American cheese
⅛ teaspoon cayenne pepper
⅛ teaspoon dry mustard
1 tablespoon salt
1 pint beer

Melt butter in top of a double boiler, add flour. Whip until smooth. Add the rest of the ingredients except beer and cook in double boiler until smooth. Add beer just before serving. (Lorraine's recipe shows Worcestershire, the newspaper shows Lea & Perrins, specifically.)

The "Family Horseshoe Sauce Recipe"

From Jan Mitello, Joe Schweska's granddaughter. There are a few differences from 1938.

½ pound unsalted butter
½ pound flour
1 quart milk (Scalded or at least room temperature, never cold.)
1 teaspoon salt
⅛ teaspoon cayenne pepper
⅛ teaspoon dry mustard
1-pound block (not commercially grated) Old English sharp or extra sharp cheddar cheese
1 tablespoon Lea & Perrins (or Worcestershire) sauce
1 pint (16 ounces) beer (Open before beginning other steps. Room temperature. Never cold. Family lore says to use flat beer.)

Melt butter in heavy, large saucepan over medium heat. Slowly add flour, whipping until smooth. Whisk in scalded (or room temperature) milk and remaining dry ingredients. Stir constantly until thickened. Remove pan from stove while grating cheese into sauce. Stir until smooth. Return pan to stovetop on low temperature. Stir in Lea & Perrins sauce. Stir in room temperature beer just before serving.

Assemble open-face sandwich on a hot plate with bread or toast, meat and desired toppings. Drizzle with cheese sauce. Arrange potato wedges or fries in a "horseshoe" around the sandwich. Serve.

This Horseshoe recipe is the first one in *Honest to Goodness: Honestly Good Food from Mr. Lincoln's Home Town*, published by the Junior League of Springfield, Illinois, 1990

½ cup butter or margarine
¼ cup flour
1 teaspoon salt
½ teaspoon freshly ground pepper
2 cups light cream or half and half
½ teaspoon cayenne pepper
2 cups shredded cheese, sharp or mild

Melt butter in saucepan. Blend in flour and cook over low heat until mixture is smooth and bubbly. Remove from heat. Stir in salt, pepper, cream, cayenne and cheese. Return to heat, stirring constantly to make a smooth, thick sauce. Keep warm until sandwich is assembled.

Place 2 slices of toast on serving plate, top with meat of your choice and cover with cheese sauce. Mound French fries on top. Serve immediately.

This recipe is reprinted with permission of the Junior League of Springfield, Illinois. Reprinting is prohibited without written permission of the JLS. Honest to Goodness cookbooks may be purchased from the Junior League of Springfield, 2800 Montvale, Springfield, IL 62704 for $24.95 plus shipping and tax. To download an order form or purchase a copy, see the website at www.jlsil.org. For more information, call (217) 544-5557.

Horseshoe recipes can be found in other recipe books. The *Kids Can Cook: Midwestern Recipes* by Mary Boone's horseshoe recipe uses milk, evaporated milk and hot sauce. In *Eat & Explore Illinois* by Anita Musgrove, the "Grilled Chicken Horseshoe Sandwich" recipe provided by Springfield Park District uses half-and-half, no dry mustard or cayenne pepper. The *Encyclopedia of American Food & Drink: With Over 500 Recipes for American Classics* by Mariani has a short description/history of horseshoes plus the cheese sauce recipe that "is said to be the original from the Leland Hotel." Instead of pounds, they use cups of flour and butter. There are some other differences, including "grated sharp cheddar cheese." The beer is definitely included.

Junior League of Springfield cookbook. *Junior League of Springfield.*

There is also a recipe in the "recipe finder" section of the *Midwest Living* magazine website. The Genius Kitchen website has several reader-contributed horseshoe recipes. The photo for the horseshoe page shows tater tots on the horseshoe. Other websites with horseshoe recipes include www.tasteofhome.com and www.beerandbrewing.com. Since many cheese sauce recipes use beer, the beer and brewing recipe makes sense, but the photo used is not a true horseshoe.

The Best of the Best from Illinois: Selected Recipes from Illinois' Favorite Cookbooks also has two horseshoe recipes. One recipe is from *Cook Book: Favorite Recipes*

from Our Best Cooks by the Central Illinois Tourism Council. The recipe is similar to the others except it suggests using either Old English cheddar or a "good Colby Longhorn cheese" and Tabasco "for the adventurous." The other recipe is the *Honest to Goodness* Junior League of Springfield recipe shown earlier.

The *State Journal-Register* used to take recipe requests. In 2003, someone requested the Wayne's Red Coach Inn horseshoe recipe. JoAnn Brawner of Seminole, Florida, submitted a recipe that was from Steve Tomko, published in the *Sangamon County Bicentennial Cookbook* compiled by the Altrusa Club of Springfield in 1975. (Brawner said she added cayenne pepper.) Used with permission of the Altrusa Club of Springfield.

Horseshoe Cheese Sauce

1 quart thick white sauce (see note)
Salt to taste
1 ½ pounds Old English cheddar cheese
2 tablespoons Lea & Perrins Worcestershire sauce
1 tablespoon prepared mustard

Combine all ingredients in double boiler and blend well. Thin with milk as needed. Serve bubbling hot over thick toast covered with ham (or other meat as desired) and French fries.

Note: Recipes for classic white sauce, also called béchamel, are available in many general cookbooks.

Unusual "Shoes"

Horseshoe Spoon
Chef Chip Kennedy
Used with permission from Secret Recipes Catering

1 pound ground Kobe beef
2 Idaho potatoes

Form the ground Kobe beef into 24 half-ounce patties and season with salt and pepper. Using a skillet over medium heat, quickly sear the patties on each side. Slice the potatoes julienne-style using a mandolin. Fry the potatoes at 300 degrees Fahrenheit until crisp (about 7 to 10 minutes).

Classic Cheese Sauce

½ cup unsalted butter
½ cup all-purpose flour
2 cups whole milk, at room temperature
1 teaspoon salt
¼ teaspoon dry mustard
⅛ teaspoon cayenne pepper
1 tablespoon Worcestershire sauce
8 ounces sharp cheddar, grated
¾ cup beer (preferably a lager), at room temperature

Melt the butter in a large, heavy saucepan over medium heat. Add the flour, and stir with a wooden spoon or whisk to combine and cook for a couple minutes until the flour loses its raw taste. Whisk in the milk, salt, mustard and cayenne pepper. Bring to a simmer and cook, stirring constantly, until the mixture is quite thick. Remove the saucepan from the stove, and then add the Worcestershire sauce and cheese, and stir until the cheese is completely melted. Whisk in the beer, and return the saucepan to the stove. Cook, stirring constantly, until the sauce comes to a slight simmer, but do not let it boil.

Place a beef patty on an appetizer spoon and pour a teaspoon of the cheese sauce on top. Then, top with a few French fries, and serve immediately. Makes 24 appetizers.

Spicy Horseshoe Sandwich
(won Illinois State Fair Horseshoe contest in 2013)
From Peggy Wise of Springfield

2 slices Texas toast

Cheese Sauce

4 tablespoons butter
4 tablespoons flour
½ teaspoon salt
1 cup milk
1 cup beer
½ teaspoon Worcestershire sauce
10 ounces Velveeta
4½ ounces pepper jack cheese

Turkey Burgers

1 pound turkey, ground
1 teaspoon garlic-pepper seasoning
½ teaspoon ground Thai pepper
¼ teaspoon salt
⅛ teaspoon pepper
⅓ cup Colby-jack cheese, shredded

Green Beans

1 cup all-purpose flour
1 cup yellow cornmeal
1 tablespoon salt
1½ teaspoons ground black pepper
½ teaspoon ground Thai pepper
Fresh green beans, ends trimmed
1 cup buttermilk

Melt butter in pan. Add flour and salt; mix well. Add milk; mix well. Add beer; mix well. Add Worcestershire, then Velveeta and pepper jack cheeses. Cook on extremely low heat for 30 minutes, stirring occasionally.

Mix all burger ingredients; form into 2 patties and cook as desired.

Mix flour, cornmeal, salt, black pepper and Thai pepper. Immerse beans in buttermilk, then transfer beans to flour mixture. Coat, then fry 5 minutes in 375-degree oil.

Butter two slices of Texas toast and grill until browned. Layer turkey burgers on top of the toast. Layer beans on top of burgers. Cover with cheese sauce. This makes 2 servings.

Charlie Parker's Diner Breakfast Horseshoe
by Mike Murphy of Charlie Parker's

The horseshoe includes a Thomas'® Original English Muffin, a couple of eggs, bacon, cheese sauce, sausage gravy and shredded hash browns.

Healthier Horseshoes

There are many ways to make horseshoes a little healthier. Substituting grilled vegetables for meat is one way. Many restaurants offer this as a choice, while others will usually be able to handle the special request of vegetables if it's not on the menu. Some restaurants offer veggie, black bean or turkey burger choices.

Nicky's added avocado to their cheese sauce. It is very good! You can add avocado/guacamole to any cheese sauce.

Making horseshoes gluten free is easy. Just use gluten-free bread and gluten-free flour in the cheese sauce.

As mentioned previously, the Prairie 'Shoe was made from turkey, chicken or a soy patty with whole wheat bread, baked fries and low fat cheese sauce. The Lincoln Land Community College culinary student winner from 2003 made cheese sauce with sauce with Neufchâtel cream

cheese and low-fat evaporated milk. She also used ground turkey breast rather than ground dark turkey to make a burger. She baked the fries and dusted them with paprika, according to an article in the *State Journal-Register*. Vegetarian Worcestershire sauce is also available to add to the cheese sauce.

Vegan Horseshoe Sandwich

From www.planteatersmanifesto.com
Reprinted with permission of Kayli Dice.

2 basic bean burgers
2 slices of whole grain bread, toasted

Fries

Russet potatoes, washed and sliced into fries
Parchment paper

Vegan Cheese Sauce

½ cup raw cashews
¾ cup water
½ cup nutritional yeast
I garlic clove, peeled
I tablespoon adobo sauce (canned) or I tablespoon salsa
Juice from ½ a lemon

Preheat oven to 400F. Arrange fries in a single layer on a parchment paper–lined baking sheet. Bake for 30–40 minutes, flipping once, until browned.

For the Vegan Cheese Sauce, combine all ingredients in a blender or food processor and blend until completely smooth. Pour sauce into a microwave-safe bowl or saucepan and gently warm on the stovetop or in the microwave.

Build your horseshoe: place one slice of toast on a plate. Top it with one bean burger and half of the baked fries. Drizzle with half of the warm vegan cheese sauce. Repeat for the second horseshoe.

<div style="border:1px solid black; padding:1em;">

VIDEO HELP

If you want to watch videos of how to create a horseshoe, there are several: Burt Wolf created a horseshoe as part of his *Local Flavors* series, episode no. 104, "Local Flavors: Springfield, Illinois." Go to www.burtwolf.com and search horseshoes or episode 104. The whole show is available to view on video or to read from the transcript.

Jeff Mauro of the Food Channel's *Sandwich King* created a Grilled Ham and Beerbit Horseshoe that included lager and sriracha along with "shoestring fries" at www.foodnetwork.com. The title is "Grilled ham with saucy fries." Sriracha is also in the cheese sauce for the Hot Turkey Horseshoe with regular fries from a 2019 The Kitchen segment entitled "Money Saving Madness."

Other videos are available on www.youtube.com by searching "horseshoe sandwich."

</div>

And Where It All Started: Welsh Rarebit or Rabbit

There are many recipes for Welsh Rarebit or Rabbit Sauce. Some that were published in cookbooks in the early 1900s are provided. These two recipes in the Boston Cooking-School Cook Book *by Fannie Merritt Farmer were published in 1906.*

Welsh Rarebit I

1 tablespoon butter
1 teaspoon cornstarch
½ cup thin cream

½ pound mild soft cheese, cut in small pieces
¼ teaspoon salt
¼ teaspoon mustard
Few grains cayenne

Melt butter, add cornstarch, stir until well mixed, then add cream gradually and cook two minutes. Add cheese and stir until cheese is melted. Season and serve on bread.

Welsh Rarebit II

1 tablespoon butter
½ pound mild soft cheese, cut in small pieces
¼ teaspoon salt
¼ teaspoon mustard
Few grains cayenne
⅓ to ¼ cup ale or lager beer
1 egg

Put butter in chafing dish, and when melted, add cheese and seasonings; as cheese melts, add ale gradually; then egg slightly beaten.

Welsh Rabbit

The Rumford Complete Cookbook *by Lily Haxworth Wallace was originally published in 1908 with annual editions for several years after.*

1 ½ pounds cheese
1 tablespoon butter
½ cup ale or milk
1 tablespoon Worcestershire
1 teaspoon dry mustard
⅓ teaspoon pepper or a little less cayenne
1 egg

This is prepared in a similar way to the other cheese sauce recipes.

BIBLIOGRAPHY

Badger, David. *Recipes from Historic Route 66*. Havana, IL: Plum Street Studio, 2010.

Bakke, Dave. "Meatless, Cheeseless: It's a Vegan Horseshoe." *State Journal-Register*, November 3, 2015.

———. "Springfield's Horseshoe Makes It to St. Louis." *State Journal-Register*, March 11, 2011.

Barras, Wanda. "From Depression Cook to Executive Chef." *Southern Illinoisan*, August 31, 1969.

Barrett, Joe. "Springfield's Horseshoe Sandwiches Deliver a Kick in the Gut." *Wall Street Journal*, March 30, 2010.

Blanchette, David. "Long Time Restaurateurs: Success Lies in Quality Food, Service, Valuing Customers." *State Journal-Register*, July 24, 2015.

Blume, Aimee. "Nut Club Festival Provides Endless Lunch Options." *Courier and Press* (Evansville, IN). October 3, 2016.

Bonner, Tanya. "Well Shod: Restaurants Vie for Horseshoe Fame." *State Journal-Register*, November 6, 1994.

Business column. *State Journal-Register*, November 9, 1997.

Cellini, Julie. "Hats Off to a New Shoe." *State Journal-Register*, March 19, 2003.

Collins, Michleen. "Horseshoe Sandwich History: Springfield's Culinary Horse Race." www.michleen-collins.com/pdf/S101p/Horseshoe_History_SF_Culinary_Horserace%20.pdf.

Daily Illinois State Journal. "Early Resident Recalls Past." March 21, 1920.

Debczak, Michele. "5 Ways to Define a Sandwich, According to the Law." *Mental Floss*, May 22, 2017.

Dellios, Hugh. "Horseshoe Isn't So Lucky for Ordinary Springfield." *Chicago Tribune*, January 6, 1992.

Dettro, Chris. "Charlie Parkers—Restaurant Owner Wins $25K Recipe Contest." *State Journal-Register*, October 27, 2015.

Editor. "Just Try a More Sensible Diet." *State Journal-Register*, February 5, 2003.

Estill, Bob. "Death Blow Dealt to Leland Hotel." *Illinois State Journal*, October 10, 1970.

Evans, Richard Paul. *The Forgotten Road*. New York: Simon & Schuster, 2018.

Fang, David. "We Tried the Horseshoe Sandwich that's So Popular in Illinois: It's On the Menu at Steak-n-Shake." December 4, 2015. www. thisisinsider.com/famous-horseshoe-sandwich-springfield-2015-12.

Fargo, Charlyn. "Calling It a Day: Fairgoers Participate in Hog, Horseshoe and Husband Contests." *State Journal-Register*, August 17, 2005.

———. "Standing the Test of Time: The Stories of Seven Springfield-Area Restaurants." *State Journal-Register*. February 12, 1999.

———. "Turtle Scoop." *State Journal-Register*, June 15, 1984.

———. "What's Cooking in Illinois? What's More Midwestern than a Horseshoe?" *Prairie Farmer*, May 18, 2018.

Fitzgerald, Jay. "Family Nails Down Ingredients for Original Horseshoe Sandwich." *State Journal-Register*, April 2, 1986.

———. "The Horseshoe: Untangling the Myths and Legends Surrounding the City's Most Famous Dish." *State Journal-Register*, February 2, 1986.

Furry, William. "Road Trip: A Gastronomical Adventure in Central Illinois." *Illinois Heritage*, July-August, 2017.

Garber, Megan, Sam Price-Waldman and Nadine Ajaka. "What Is a Sandwich? (No, Seriously, Though)." *Atlantic*, September 10, 2014.

Gilkison, Julie. "Horseshoe Sandwich: Springfield's Other Claim to Fame." http://www.americanfoodroots.com/50-states/horseshoe-sandwich-springfields-claim-fame. March 3, 2014.

Glatz, Julianne. "What Happened to Horseshoes?" *Illinois Times*, February 2, 2012.

Gonko, Bob. "Close Counts, With Horseshoes." *State Journal-Register*, December 26, 1979.

———. "Wait, New Horseshoe Evidence." *State Journal-Register*, January 2, 1980.

Hardy, Thomas. "Horseshoe Critic Eats Half His Words." *Chicago Tribune*, June 10, 1990.

Harmon, Carolyn. "Horseshoes: A Springfield Phenomenon." *Springfield Magazine*, February 2000.

Henderson, Pam, and Jan Mathew. *You Know You're in Illinois When…* Guilford, CT: Globe Pequot Press, 2006.

Illinois State Register. "Historic Leland Burned in 1908." June 25, 1911.

Jakle, John, and Keith Sculle. *Fast Food: Roadside Restaurants in the Automobile Age*. Baltimore: Johns Hopkins University Press, 2002.

Long, Joanne. "Springfield's Sandwich of Distinction." *State Journal-Register*, February 19, 1972.

Marketplace. "Towne Lounge Has Homemade Pies." *State Journal Register*, November 6, 2005.

McClanahan, Jerry. *The EZ66 Guide for Travelers*. 3rd ed. Lake Arrowhead, CA: National Historic Route 66 Federation, 2014.

McDaniel, Toby. Column. *State Journal-Register*, July 24, 1993.

———. Column. *State Journal-Register*, April 12, 2004.

Mitchell, Dorian. "Feel at Home in the Country Kitchen." *Star-Democrat* (Easton, MD), March 25, 2016.

Moreno, Richard. *Illinois Curiosities*. Guilford, CT: GP Putnam, 2011.

Morrison, Ann. "36 Hours in Springfield Illinois." *New York Times*, July 14, 2006.

Morrow, Elise. "Springfield, Illinois." *Saturday Evening Post*, September 27, 1947.

Murdock, Andy. "Field Guide to 20 Great Regional Sandwiches of the USA." *Lonely Planet*, August 31, 2012.

Ozersky, Josh. "United States of Sandwiches." *Esquire*, September 2014.

Raynolds Johnson, Katie. *Goodnight Springfield*. Chicago: Paisley Publishing, 2013.

Rem, Kathryn. "A First for the Fair." *State Journal-Register*, August 12, 2012.

———. "Illinois State Fair—Fair Contest Unleashes the Creativity." *State Journal-Register*, August 14, 2013.

———. "Local Eateries Create the Obama Horseshoe." *State Journal-Register*, January, 21, 2009.

———. "'Shoe Fetish: All Kinds of Options Are Out There for Horseshoes." *State Journal-Register*, August 12, 2009.

Rodeghier, Katherine. "Must-Eat Midwest Dishes from 5 States." *Chicago Tribune*, March 20, 2017.

Selvam, Ashok. "Chicago White Sox Will Serve Springfield's Famous Horseshoe Sandwich This Season." March 14, 2018. https://www.southsidesox.com/2018/3/15/17123018/south-side-horseshoe-to-make-its-debut-yum-yum.

———. "The Horseshoe: Where to Find the Illinois Capital's Favorite Sandwich." June 14, 2017. https://chicago.eater.com/maps/best-horseshoe-sandwiches-springfield-illinois-road-trip.

Stapleton, Susan. "Meet the Most Iconic Dish of the Quad Cities—The Magic Mountain." *Des Moines Register*, November 25, 2015.

State Journal-Register. "Horseshoe Is Going Regional." September 22, 2002.

———. "Java Dog Offering Favorite Blends." May 30, 1999.

———. "Office Sports Bar & Grill Opens in Montvale Plaza." March 2, 1997.

Stern, Jane, and Michael Stern. *500 Things to Eat Before It's Too Late*. Boston: Houghton-Mifflin Harcourt, 2009.

———. *Lexicon of Real American Food*. Guilford, CT: Lyons Press, 2011.

———. *Road Food Sandwiches*. NY: Houghton-Mifflin, 2007.

Travel. "50 Cities Known for a Specific Food." *Huffington Post*, March 14, 2014.

Ward, Alvin. "Best Sandwich from Every State." *Mental Floss*, April 13, 2015.

Ward, Bill. "The Subject Is Horseshoes." *Springfield Limited Edition*, a publication of the *Herald & Review*, December 1994.

What's Cooking America (Linda Stradley). "Horseshoe Sandwich Recipe and History." May 21, 2015. https://whatscookingamerica.net/History/Sandwiches/HorseshoeSandwich.htm.

Wheeler, Robin. "Battle Horseshoe: Moore's Restaurant vs. Horseshoe House." *Riverfront Times*, April 12, 2011.

Willett, Megan. "50 Most Famous Sandwiches Across America." *Business Insider*, November 4, 2013.

Woods, Robert. "Experience, Accuracy Basis on Savory Dishes Say Chefs Who Give Favorite Recipes." *Illinois State Journal*, December 25, 1938.

Zimmerman-Wills, Penny. "Guess What They've Fried This Year." *Illinois Times*, August 11, 2005.

Zvereva, Stevie. "Follow That Horse…Shoe." Art & Society, September-October, 2014. https://peoriamagazines.com/as/2014/sep-oct/follow-horseshoe.

The Sangamon County Historical Society provides the *Sangamon Link*, which has information about historic Springfield restaurants and Horseshoes. Searches are available at: www.sangamoncountyhistory.org.

BIBLIOGRAPHY

Facebook and Instagram

"The Horseshoe," the "Horseshoe Sandwich—Signature Dish of Springfield, Illinois" pages, "Pursuing the Horseshoe Sandwich" group and the "Memories of Springfield" group (horseshoe thread).

Blog

www.horseshoequest.blogspot.com

Recipes

Boone, Mary. *Kids Can Cook: Midwestern Recipes*. Newark, DE: Mitchell Lane Publishers, 2012.

Farmer, Fannie Merritt. *Boston Cooking–School Cook Book*. Boston: Little Brown & Co., 1906.

Helm, Susan. *Honest to Goodness: Honestly Good Food from Mr. Lincoln's Home Town by the Junior League of Springfield*. Springfield, IL: Junior League of Springfield, 1990.

Mariani, John. *The Encyclopedia of American Food & Drink: With Over 500 Recipes for American Classics*. New York: Bloomsbury, 2013.

McKee, Gwen, and Barbara Moseley, eds. *Best of the Best from Illinois: Selected Recipes from Illinois' Favorite Cookbooks*. Brandon, MS: Quail Ridge Press, 1995.

Musgrove, Anita. *Eat & Explore Illinois: Cookbook and Travel Guide*. Brandon, MS: Great American Publishers, 2017.

SPARC. *Springfield Eats: A Book of Capital Cuisine Cookbook*. Springfield, IL: SPARC, 1994.

Wallace, Lily Haxworth. *Rumford Complete Cookbook*. Providence, RI: Rumford Chemical Works, 1908.

Audio/Video

Cappe, Noah. *Carnival Eats*. Cooking Channel, 2014.

Chillag, Ian. *Sandwich Mondays/Segal, Peter, Wait, Wait, Don't Tell Me*. NPR, October 2010.

Cooking Channel, *Carnival Eats*. Season 1, episode 10. "Illinois State Fair."

Fieri, Guy. "Regional Favorites." *Diners, Drive-Ins and Dives*, Food Network, 2009.

Mauro, Jeff. "Indulgent Bites." *Sandwich King*, 2013.

———. "Money Saving Madness." *The Kitchen*, 2019.

Maldaner's. Food Channel, 2017.

Richman, Alan. *Man v. Food*, 2011.

Roker, Al. *Roker on the Road*, 2004.

Wolf, Burt. *Travels and Traditions: Local Flavors #104, Springfield, IL*. November 4, 2016.

INDEX

ABOUT THE AUTHORS

 arolyn Harmon is a retired educator and freelance writer who has enjoyed sampling horseshoes for many years. She continues to perfect her family's recipe for potatoes and cheese sauce, the horseshoe's most important component.

 ony Leone has often served as a historical reference for the horseshoe sandwich for local and national publications. Leone restored a Springfield landmark, the Pasfield House Inn, former residence of George Pasfield, who served as president of the Leland Hotel when the horseshoe sandwich was created.

Visit us at
www.historypress.com

··